Dedalus European C
General Editor: Mike Mitchell

The German Refugees

Johann Wolfgang von Goethe

The German Refugees

Translated with a chronology and
introduction by Mike Mitchell

Dedalus

LOTTERY FUNDED

Published in the UK by Dedalus Ltd,
Langford Lodge, St Judith's Lane, Sawtry, Cambs, PE28 5XE
email: DedalusLimited@compuserve.com
www.dedalusbooks.com

ISBN 1 903517 44 3

Dedalus is distributed in the United States by SCB Distributors,
15608 South New Century Drive, Gardena, California 90248
email: info@scbdistributors.com web site: www.scbdistributors.com

Dedalus is distributed in Australia & New Zealand by Peribo Pty Ltd,
58 Beaumont Road, Mount Kuring-gai N.S.W. 2080
email: peribo@bigpond.com

Dedalus is distributed in Canada by Disticor Direct-Book Division,
695 Westney Road South, Suite 14 Ajax, Ontario, LI6 6M9
web site: www.disticordirect.com

Publishing History
First published in Germany in 1795
Mike Mitchell's translation published by Dedalus in 2006
Translation © copyright Mike Mitchell 2005

The right of Mike Mitchell to be identified as the translator of this book has been
asserted by him in accordance with the Copyright, Designs and Patent Act, 1988.

Printed in Finland by WS Bookwell
Typeset by RefineCatch Limited, Bungay, Suffolk

This book is sold subject to the condition that it shall not, by way of trade or
otherwise, be lent, resold, hired out, or otherwise circulated without the publisher's
prior consent in any form of binding or cover other than that in which it is published
and without a similar condition including this condition being imposed on the
subsequent purchaser.

A C.I.P. listing for this book is available on request.

THE TRANSLATOR

Mike Mitchell is one of Dedalus's editorial directors and is responsible for the Dedalus translation programme. His publications include *The Dedalus Book of Austrian Fantasy, Peter Hacks: Drama for a Socialist Society* and *Austria* in the *World Bibliographical Series*. His translation of Rosendorfer's *Letters Back to Ancient China* won the 1998 Schlegel-Tieck Translation Prize after having been shortlisted in previous years for his translations of *Stephanie* by Herbert Rosendorfer and *The Golem* by Gustav Meyrink. His translation of *Simplicissimus* was shortlisted for The Weidenfeld Translation Prize in 1999 and *The Other Side* by Alfred Kubin in 2000.

He has translated the following books for Dedalus from German: five novels by Gustav Meyrink, three novels by Johann Grimmelshausen, three novels by Herbert Rosendorfer, two novels by Hermann Ungar, *The Great Bagarozy* by Helmut Krausser, *The Road to Darkness* by Paul Leppin, *The Other Side* by Alfred Kubin. From French he has translated for Dedalus two novels by Mercedes Deambrosis and *Bruges-la-Morte* by Georges Rodenbach.

He is currently working on a translation of *Grand Solo for Anton* by Herbert Rosendorfer which Dedalus will publish in 2006.

MAIN DATES OF GOETHE'S LIFE

1749	born Johann Wolfgang Goethe in Frankfurt am Main, August 28
1765–68	studies (rather reluctantly) law in Leipzig; after a serious illness continues studies in Strasbourg 1770–71; briefly a trainee at the court in Wetzlar (1772), but never practises as a lawyer
1770–71	love for Friederike Brion; early lyrics
1771	Frankfurt; *Sturm und Drang* drama *Götz von Berlichingen*
1772	Wetzlar; love for Charlotte Buff, a friend's fiancée, provides material for *Werther*, 1774
1775	April: engagement to Lili Schönemann, broken off in autumn; November: goes to Weimar at invitation of Duke of Saxe-Weimar; appointed to Weimar civil service in 1776 and remains in Weimar until death in 1832; first meeting with Charlotte von Stein, friendship to 1788
1776–86	high-ranking official in Weimar, e.g.: 1779 – head of commission for roads and war; 1782 – ennobled; 1784 – responsible for mines; scientific studies: mineralogy, anatomy, botany; lectures on anatomy, 1781; discovers

	intermaxilliary bone 1784; *Metamorphosis of Plants*, 1790; *Theory of Colour*, 1810; first version of *Wilhelm Meister* (1777), *Iphigenie* (1779)
1786–88	secretly leaves Carlsbad for Italy, stays away almost 2 years; beginning of his classicism: *Iphigenie* in verse form; *Torquato Tasso; Roman Elegies*
1788	returns to Weimar; responsibilities (apart from the mines) now mainly for science and the arts; meets Christiane Vulpius, their son born in 1789, they eventually marry in 1806
1790	*Faust, ein Fragment* published
1791–1817	director of Weimar court theatre
1792	takes part, as member of Duke's entourage, in the campaign in France; 1793 observer at siege of Mainz
1794	*The German Refugees*
1794–1805	friendship with Schiller
1796	*Wilhelm Meister's Years of Apprenticeship*
1797	the 'ballad year' during which he and Schiller wrote many of their best-known ballads
1806	*Faust I* completed; French occupy Weimar; meets Napoleon in 1808
1809	*Elective Affinities*
1811	part one of autobiography *Poetry and Truth* (others 1812, 1813, 1830)
1816	death of his wife

1819	*West-Eastern Divan*
1822	*The Campaign in France* completed
1825–1831	*Faust II*
1829	*Wilhelm Meister's Travels* completed
1832	dies March 22

INTRODUCTION

Goethe's *Unterhaltungen deutscher Ausgewanderten* is generally mistranslated in English as the *Conversations* of German refugees. Although *Unterhaltungen* can, of course, mean 'conversations', in this book the word is generally used in the sense of 'amusements' or 'entertainments', much along the lines of the old title of the *Thousand and One Nights: The Arabian Nights' Entertainments*. What these 'entertainments' might consist of is indicated by the Baroness, the head of the refugee household: talks on distant countries, their customs and traditions, or on ancient and modern history; poems read out; philosophical reflections on unusual stones, plants or insects brought back from a walk. They are the amusements of a cultured, leisured society and one of Goethe's themes in the book is the nature of 'polite' society.

In fact, however, what we have in this book is not the pastimes the Baroness lists, but a series of stories told by members of the group, together with their discussions about them. *The German Refugees*, then, is the first day of a German *Decameron*. There are seven stories in all: two ghost stories, two love stories, two moral tales and the 'fairy tale'. Not all are original: the two love stories are taken, almost word for word, from the *Mémoires du Maréchal de Bassompierre* and the story of the attorney adapts one from the *Cent nouvelles nouvelles*; the two ghost stories Goethe wrote following anecdotes he had

11

heard from acquaintances; the story of Ferdinand and the fairy tale are original compositions. Goethe did plan a further volume, but never got round to writing it.

The situation is parallel to that in Boccaccio: a group of nobles in a country house on the right bank of the Rhine. The 'plague' these German aristocrats have fled from is the French Revolution, which has driven them out of their home on the left bank of the river. And it is the Revolution that gives rise to the storytelling. Karl, a young firebrand, is a supporter of the ideals of the Revolution. This leads to such violent arguments with Herr von S., a high-ranking official, that the latter leaves in disgust, together with his wife, a childhood friend of the Baroness. The Baroness then reminds the group of the decorum which is essential if society is to function smoothly, bans political discussions and suggests they return to the cultured amusements of more peaceful times. The old priest offers some examples from his collection of tales, and starts the process by telling the first two stories.

Goethe had personal acquaintance with the disruption caused by the revolutionary wars. (He used it as the background to another work, one of his most popular, the epic poem *Hermann and Dorothea*.) The Duke of Saxe-Weimar was a Prussian general and Goethe participated in two campaigns as a member of his entourage. In his account of his experiences, *The Campaign in France*, he claimed to have told the others, when the coalition forces were repulsed by the French at Valmy in 1792, 'Here and

today a new era in the history of the world has begun, and you can say you were there.' He was merely an observer, though he did step in when the French withdrew after the siege of Mainz (1793) to stop the locals attacking a German Jacobin who was leaving with them. In *The German Refugees* this incident becomes a prophecy Herr von S. uses to taunt Karl.

Some of the comments Goethe himself made on the *ancien régime* could have come from the lips of his revolutionary idealist Karl. He described the Bourbon monarchy as a 'pit of immorality', for example. But he was no supporter of the Revolution; his attitude was more one of 'a plague on both your houses'. As he later explained to his secretary Eckermann: 'It is true I could not support the Revolution, I was too close to its atrocities . . . while at that time its beneficial effects were not apparent . . . But I was no more a supporter of tyranny. Also I was convinced that it is not the people who are to blame for a revolution, but the government.'

Goethe hated politics anyway – 'A nasty song, fie, a political song' a character says in *Faust* – but the idea of revolution was contrary to his whole outlook. In his scientific studies he developed the idea of metamorphosis as fundamental to organic growth, and in geology he was a Neptunist who believed the gradual action of water was more fundamental than the eruptive action of fire proposed by the Vulcanists. His whole view of the world was based on evolution rather than sudden, violent change. During the revolutionary and Napoleonic wars he stood *au*

dessus de la mêlée, the first sign, perhaps, of the 'Olympian' Goethe of his later years. During the campaign he complained to his friend Jacobi that all he wanted to do was to get home 'where I can gather a circle round me which will let nothing in but love and friendship, art and science.' *The German Refugees* shows the establishment of just such a circle.

After early works in the elegantly playful rococo style, Goethe was converted, in part by the influence of Herder, to 'German' art – to Gothic architecture, folk poetry and the vigour of Shakespearean dramatic form. This movement of the 1770s exalting nature, freedom and dynamism is generally known in England as 'Storm and Stress,' a translation of the term *Sturm und Drang*. Perhaps more appropriate is the other German term for the period, the *Geniezeit*, an explosive period when young writers followed their own genius and rejected all convention, literary or social. The attitude could perhaps be best characterised by the quotation from Goethe's play of the time, *Götz von Berlichingen*, which is still known in German as the 'Götz quotation': 'Go kiss my arse'.

It was at Weimar, and largely due to the influence of Frau von Stein, that the wild 'genius' was tamed and turned into a conscientious administrator with serious scientific as well as artistic interests. But after ten years of this settled existence, the burden of duty became onerous and he escaped to Italy, where he spent two years 'playing truant' in the sun. What he sought there, even more than the pleasant climate, was contact with classical art, direct, physical contact. In Italy he became a highly conscious

artist for whom form was not a mere convention, nor a convention to be broken, but an integral part of the whole. When he returned home it was as a proselyte, keen to convert his fellow-countrymen to his new-found ideal of classical art. The German public, however – as far as one can talk of a public in that disunited nation – was not interested and Goethe's classicism remained, especially after the death of Schiller in 1805, a personal affair.

The German Refugees is a product of this classicism. It takes, adapts and develops a model from the past, not only *The Decameron*, but also classical works which incorporate separate stories in a narrative, such as the *Satyricon* or *The Golden Ass*. Its style, too, avoids the vivid, specific detail, the striking image, for a generalising vocabulary in which the same words appear again and again.

The feature that stands out from the rest and, in some ways, disturbs its harmony, is the the fairy tale with which it finishes. Even the way it is included in the book sets it off from the rest, and it is often published separately. It is not a fairy tale in the sense of the folk tale propagated by the Romantics, but a highly complex symbolic structure, a cryptic narrative combining motifs from a wide variety of sources. It also contains an element of conscious irony foreign to the traditional fairy tale. With its richness of texture and wealth of imagination it also sounds improbable on the lips of the dry-as-dust Kantian, the old priest, who supposedly narrates it. That is presumably why, although the priest promises to tell the company 'a fairy tale that will remind you of

everything and nothing', it is not actually presented as coming from his lips. It is given a title, which no other story has, and then set down in neutral form, with no personal comments from the priest. It explodes the structure Goethe has set up, but it is such a magnificent explosion, surely no reader will object?

THE GERMAN REFUGEES

In those unhappy days which had the most painful
consequences for Germany, for Europe, indeed, for
the rest of the world, when the French army broke
through a poorly defended gap into our fatherland,
a noble family left their estates there and fled
across the Rhine to avoid the oppression threatening
all persons of note, who were treated as criminals
because of the respect and honour in which they
held their forefathers, as well as for the fact that
they enjoyed advantages which any right-thinking
father would wish to secure for his children and his
children's children.

It was a comfort to her children, relatives and
friends that Baroness von C., a widow in the prime
of life, proved as energetic and resolute during
their flight as she had at home. Brought up in the
wider world and moulded by a variety of experi-
ence, she was well-known as an excellent housewife
and her keen mind seemed to relish any kind of
challenge. Her desire was to be of service to many,
and her extensive circle of acquaintances made it
possible for her to do so. Now she had to act as
leader of a small caravan and showed herself cap-
able of guiding it, looking after our refugees and
keeping them in good humour amidst all their fear
and distress. And, indeed, they were quite often in
a good mood, surprising events and new situations

giving their strained spirits occasion for jokes and laughter.

On their precipitate flight, the behaviour of each member was strikingly characteristic. One would get carried away by a baseless fear, an unfounded terror, another would be concerned with unnecessary worries, and every overreaction, every oversight, every case of weakness revealing itself in resignation or overhastiness gave rise to much mutual teasing and ridicule, turning this distressing situation into a more pleasurable occasion than a pleasure trip in former, happier times.

Just as we can watch a comedy for a time without laughing at the intentional jokes, while we immediately burst out into loud laughter when something untoward happens in a tragedy, so a misfortune in the real world that shakes people out of their composure will usually be accompanied by ridiculous circumstances which give rise to immediate, or at least subsequent laughter.

In this respect the Baroness's eldest daughter, Fräulein Luise, a lively, passionate young woman with, on good days, a commanding presence, had much to put up with. It was maintained that the first shock had thrown her completely off balance; in a fit of absentmindedness, a kind of abstraction even, she had solemnly brought the most pointless objects to be packed and had even taken an old servant for her fiancé.

She defended herself as well as she could. The only thing she refused to allow were jokes about her fiancé; as it was, she suffered enough from knowing

he was with the allied army, in daily danger, and from seeing a desired union postponed, perhaps even rendered impossible.

Her elder brother Friedrich, a resolute young man, carried out all his mother's decisions carefully and precisely, accompanying the procession of carriages and carts on horseback, acting as escort, baggage-master and guide in one. The promising younger son's tutor, a well-informed man, kept the Baroness company in her carriage; Cousin Karl came in a following carriage, together with an old priest, who had long been an indispensable friend of the family, and one older and one younger relative. Chambermaids and manservants followed in half-open chaises, and the procession closed with several heavily laden carts, more than one of which had to be left behind at various stages on their journey.

As one can well imagine, the whole company were unhappy to leave their homes, but Cousin Karl was doubly reluctant to abandon the left bank of the Rhine. Not that he was leaving behind a sweetheart, as one might imagine from his young years, his handsome figure and his passionate nature; rather he had been seduced by that dazzling beauty which, under the name of liberty, had managed to acquire, at first secretly, then openly, so many admirers and, however badly she treated some, was most fervently adored by the others.

Love is blind, they say, and that was certainly true of Cousin Karl. Lovers desire to possess one thing alone and imagine they can dispense with everything else. Rank, worldly goods, other relationships are as

nothing to them, as the one thing they desire comes to mean everything. We forget parents, relatives and friends as we acquire something which occupies us completely, to the exclusion of everything else.

Cousin Karl abandoned himself to the violence of his passion and did not conceal it in conversation with others. He believed he could express these opinions all the more freely because he was of noble birth himself and, although the second son, could expect to inherit a considerable fortune. At the moment the estates which were destined for him were in the hands of the enemy, who were not exactly treating them kindly. Despite this, Karl refused to feel hostility towards a nation which was promising the world so many benefits and whose intentions he judged from the public speeches and remarks made by certain members of it. He regularly disturbed the company's mood of contentment, as far as they were capable of that anyway, by exaggerated praise of everything, good or evil, the New French were doing, by loud expressions of pleasure at their progress, which irritated the others all the more, the smug satisfaction of a friend and relative only making their sufferings doubly painful to bear.

Friedrich had had several disagreements with him and eventually simply kept out of his way. The Baroness was adept at getting him to moderate his expression, if only temporarily. It was Fräulein Luise who gave him the most difficult time by casting doubts, often unjustly, on his character and sanity. The tutor silently agreed with him, the priest, just as silently, disagreed, and the chambermaids, who

found his figure attractive and his liberality commendable, liked to hear him talk because they believed the opinions he expressed justified them in directing the loving glances, which previously they had modestly cast down, openly at him.

Generally the requirements of daily life, the obstacles they met on the way and the discomforts of their accommodation brought the company back to matters of immediate importance, and the great number of French and German refugees they encountered everywhere, with such a wide variety of attitudes and experiences, often made them reflect how necessary it was during those times to moderate one's behaviour, especially to avoid taking sides and to keep on good terms with others.

One day the Baroness remarked that one could not see more clearly than at such moments of confusion and distress how uneducated people were in every sense. 'Society as it is at present constituted,' she said, 'seems to be like a ship that can carry a large number of people, young and old, well and infirm, over dangerous waters, even in times of storm; only when the ship is wrecked does one see who can swim, and in such circumstances even good swimmers perish.

'We mostly see the refugees take their weaknesses and foolish habits with them on their wanderings and find it surprising. But just as the Englishman is inseparable from his teapot on his journeys to the four corners of the world, so the general mass of people are accompanied everywhere they go by pretensions, vanity, intemperance, impatience,

21

obstinacy, poor judgment and the desire to do ill to their fellow men. A frivolous person treats the flight as a pleasure trip and an overindulgent one expects everything to be at his service even though he is now a beggar. How rarely is it that we see pure virtue in a person who is truly impelled to live, to sacrifice himself for others.'

While they made the acquaintance of various people who gave rise to such reflections, the winter had passed. The fortunes of war once more favoured the Germans, the French had been thrown back over the Rhine, Frankfurt liberated, Mainz blockaded.

Hoping the army would continue victorious, and eager to retrieve part of their property, the family hastily made their way to an estate belonging to them on the right bank of the Rhine. How it revived their spirits to see once more the beautiful river flowing past their windows, how great was their joy as they took possession of every part of the house again, greeting the familiar furnishings, the old pictures, even ordinary household utensils as old friends, how valuable even the least items they had given up as lost now seemed, and how their hopes rose of one day finding everything on the other side of the Rhine also still in its old condition!

Scarcely had the report of the Baroness's arrival spread through the neighbourhood than all their old friends, acquaintances and servants hurried over to talk to her, to recount the stories of the previous months and, in many cases, to ask her advice and support.

Surrounded by these visitors, she was most pleasantly surprised when Herr von S. arrived, a privy councillor, a man for whom from his youth the business of government had become a necessity, a man who deserved and possessed the confidence of his prince. He was a stickler for principle and had his own ideas on many things. He was very precise in all he said and did, and demanded the same of others. Consistency seemed to him the supreme virtue.

His prince, his country and he himself had all suffered considerably through the French invasion; he had come to know the arbitrary exploitation of power by the nation that spoke only of law, the despotism of those who were always talking of liberty. He had seen that in this case, too, the great mass had remained true to itself, responding with violence as they took the word for the deed, appearance for reality. He clearly saw the consequences of an unfortunate campaign as well as of those widespread attitudes and opinions, although it could not be denied that he viewed some things with a jaundiced eye and condemned them with vehemence.

After so many afflictions, his wife, a childhood friend of the Baroness, was overjoyed to be in the arms of her friend. They had grown up together, had been educated together and had no secrets from each other. The first affections of their young years, the delicate situations of marriage, their joys, worries and sorrows as mothers, everything they had confided to each other, partly by word of mouth, partly by letter, and had remained in unbroken contact. Only during the recent times had the unrest

prevented them from keeping in touch with each other. Their present conversations, therefore, poured forth in all the more lively flow, they had all the more to tell each other, while Frau von S.'s daughters spent their time in growing intimacy with Fräulein Luise.

Unfortunately their enjoyment of this charming area was often disturbed by the thunder of the cannon, which they could hear in the distance, more or less clearly, depending on the direction from which the wind was blowing. Given the flood of news arriving, it was equally impossible to avoid political discussions, which usually immediately disturbed the company's mood of content, as the different views and opinions on both sides were expressed in most lively fashion. And just as self-indulgent people cannot abstain from wine and rich food, even though they know from experience that it will immediately lead to nausea, most of the members of the company found it impossible to restrain themselves in this matter, yielding to the irresistible urge to hurt others and, in the end, make things unpleasant for themselves too.

As one can well imagine, it was Herr von S. who led the party supporting the old system and Karl who spoke for the opposing one, which hoped imminent reforms would revive and revitalise the old, sickly body politic.

At first these discussions were fairly restrained, especially since the Baroness managed to keep the two sides in check with her urbane interjections. As, however, the important stage approached when the

blockade of Mainz was to become a full-blown siege and they began to entertain more lively fears for that beautiful city and its remaining inhabitants, they all expressed their opinions with unbridled passion.

The discussions centred in particular round the German Jacobins who were still there, each person expecting them to be either punished or freed, depending on whether he approved or disapproved of their actions.

Among the latter was Herr von S., whose arguments, casting doubts on their sanity and accusing them of a complete lack of understanding of the world and their own selves, most annoyed Karl.

'How blind they must be,' the privy councillor exclaimed one afternoon when the discussion started to get very heated, 'if they imagine that a huge nation, fighting with itself in the greatest confusion and even in moments of calm with no thought but for itself, will look on them with any sympathy. They will be seen as instruments, to be used for a while, then thrown away, or at least ignored. They are very much mistaken if they believe they can ever be counted among the French.

'There is nothing that appears more ridiculous to any great and powerful person than a little, weak man who, blinded by his self-delusion, ignorant of himself, his strength and his relative position, imagines himself the other's equal. And do you imagine that, after the good fortune with which it has so far been favoured, the great nation will be less proud, less arrogant than any other, royal victor?

'Many a man, who at the moment is a municipal

officer, running round in a tricolour sash, will curse the charade when, after having helped to force his fellow-countrymen into a new, repugnant system, he finds himself, in this new system, treated with contempt by those in whom he placed his whole trust. Indeed, I think it highly likely that at the surrender of the city, which probably cannot be delayed much longer now, such men will be abandoned or handed over to our forces. Then let them take their reward, then let them take the chastisement they deserve, that is my considered, impartial judgment.'

'Impartial!' Karl exclaimed vehemently. 'Don't let me hear that word again! How can one condemn these men out of hand like that. True, they haven't spent their youth, their whole lives exploiting the traditional system to their own advantage and to that of other privileged people; true, they haven't occupied the few habitable rooms of the old building and made themselves comfortable in them; rather they were exposed to the discomforts of the neglected parts of your palace of state because they had to spend their lives there, wretched and oppressed; they hadn't been seduced by the ease of duties performed mechanically into regarding what they had become accustomed to doing as good; true, they could only look on in silence at the one-sidedness, the disorder, the inefficiency, the incompetence of your statesmen, who still believe what they do should earn our respect; true, they could only wish in secret that labour and enjoyment were shared out more equally! And who can deny that among them there are at least some perceptive

and able men who, even if at the moment they are
not in a position to realise the ideal, are fortunate to
be able, though their mediation, to mitigate the
effects of a disastrous situation and prepare the way
for something better; and since there are such men
among them, who will not feel sorry for them as
the moment approaches which may rob them of all
their hopes for ever.'

Herr von S. responded with a joke, a rather bitter
joke, about young people's tendency to idealise
things; Karl, for his part, was not sparing in his criti-
cism of those who could only think in the old ways
and were thus bound to reject anything that did not
fit in with them.

As the argument went back and forth, the discus-
sion became more and more heated on both sides and
all the things came up which had brought dissension
to many a happy gathering during recent years. In
vain the Baroness attempted to bring about if not
peace, then a truce; even Frau von S., who, through
her charm, had acquired some influence over Karl,
could not calm him down, especially since her hus-
band continued to fire off his well-aimed darts at
youth and inexperience, mocking children's habit of
playing with fire they cannot control.

Karl, who was beside himself with fury, made no
secret of the fact that he wished the French army all
success and that he called on every German to put an
end to the old slavery; that he was convinced the
French nation would appreciate those high-minded
Germans who had come out on their side, would
regard and treat them as their own, not sacrifice

them, or leave them to their fate, but heap honours, wealth and trust on them.

Herr von S. retorted that it was ridiculous to imagine that the French, when they capitulated or whatever, would look after them for one moment; on the contrary, those people would fall into the hands of the allies and he hoped to see them all hanged.

That threat was too much for Karl, and he shouted that he hoped the guillotine would reap a fine harvest in Germany as well and that not one guilty head would escape, adding a number of severe criticisms which were directed at Herr von S. personally and were in every sense insulting.

'In that case,' said Herr von S., 'I shall be obliged to leave a company where nothing that was formerly considered worthy of respect is esteemed any more. I am sorry to have been driven out again, and this time by a fellow-countryman, but I can see that I can expect harsher treatment from him than from the New French. It confirms the old adage that it is better to fall into the hands of the Turks than of the renegade Christians.'

With that he stood up and left the room; his wife followed him. The company were silent. With a few, strong words the Baroness expressed her displeasure; Karl was pacing up and down. Frau von S. came back in tears and told them her husband was having their things packed and had already ordered the horses. The Baroness went to try and get him to change his mind, the girls wept and embraced, dismayed that they should have to part so soon and so unexpectedly. The Baroness returned; she had been

unsuccessful. Gradually everything that belonged to the visitors was gathered together piece by piece. The sad moments of separation and parting were very keenly felt. All hope vanished along with the last caskets and boxes. The horses came and the tears flowed even more copiously.

The carriage drove off and the Baroness watched it leave, her eyes full of tears. She stepped back from the window and sat down at her embroidery frame. The whole company was silent, embarrassed even. Karl, especially, showed his unease; he sat in a corner, leafing through a book and casting occasional glances at his aunt. Eventually he stood up and took his hat, as if he were going to go out; at the door, however, he turned round, went over to the embroidery frame and said, with a composure that betrayed noble feeling, 'Dear Aunt, I have offended you, I have caused you pain. I got carried away, please forgive me; I admit I was wrong, and I feel it deeply.'

'I can forgive you,' the Baroness replied. 'You are a fine, noble young man and I will not bear a grudge. But you cannot make good what you have spoilt. Through your fault I am denied the company of a friend I had not seen for a long time, a friend who was brought to me by misfortune and in whose company I could, for a while, forget the fate that has struck us and still threatens us. And now she, who had been driven hither and thither for so long in fearful flight and had but a few days respite in the company of friends she loved, in a comfortable house, in a pleasant place, must set off once again. And we have lost the entertaining company of her

husband; he may have his odd, eccentric ways, but still he is a decent, honest man, inexhaustible in his knowledge of people and the ways of the world, a veritable archive of events and circumstances, with the ability to present it in a light, easy and pleasant manner. Your violent temper has deprived us of all this; how do you propose to make up for what we have lost?'

Karl: 'Spare me, dear Aunt. I feel the error of my ways keenly enough as it is, do not force me to see the consequences so clearly.'

Baroness: 'On the contrary, you must look at them as clearly as possible. It is not a matter of sparing your feelings, the only question is whether you can see the error of your ways. It is not the first time you have made this mistake, nor will it be the last. Oh what is man that the desperate plight which crowds you together under *one* roof, in *one* cramped hut, cannot make you tolerant of each other?! Are there not enough monstrous things happening, rolling inexorably towards you and yours? Can you not look to yourselves and behave in a moderate and reasonable manner towards those who, after all, do not want to take, to steal anything from you? Must you let your feelings erupt so blindly, so inexorably, and hit out like historical events, or a storm or any other natural catastrophe?'

Karl did not answer, and the tutor, who had been standing by the window, came over to the Baroness and said, 'He will mend his ways. This occurrence will be a warning to him, to us all. We will examine ourselves daily, we will keep in mind the pain

you have suffered; we will show that we, too, have ourselves under control.'

Baroness: 'How easily men manage to convince themselves, particularly on that point! They find the word *mastery* so pleasant, it sounds so superior to be able to *master* one's feelings. They love talking about it and would have us believe they were serious about putting it into practice. I wish I had come across a single one in my life who was capable of mastering his feelings in even the most trivial things! In matters of indifference to them, they put on a serious air, as if they were making a great effort to deny themselves, but they are very good at presenting, both to themselves and others, things they passionately desire as admirable, essential, unavoidable and indispensable. I could not tell you of a single man who is capable of the least self-denial.'

Tutor: 'You are rarely unjust and I have never seen you so overcome with annoyance and strong emotion as now.'

Baroness: 'At least I have no reason to be ashamed of that emotion. When I think of my friend, in her carriage, on uncomfortable roads, tearfully remembering the violation of the laws of hospitality, it makes me furious with all of you.'

Tutor: 'Even during our greatest misfortunes I have never seen you as carried away, as impassioned as at this moment.'

Baroness: 'A minor misfortune following on a greater one fills the cup to overflowing; and I do not consider it a minor misfortune to be denied the company of a friend.'

Tutor: 'Compose yourself and trust us to mend our ways, to do everything possible to satisfy you.'

Baroness: 'Certainly not! None of you will coax me into trusting him. In future I will *require* things of you, I will give the orders in my house.'

'Order away! Require things of us,' cried Karl, 'and you will have no reason to complain about our disobedience.'

'My discipline will not be quite that strict,' replied the Baroness with a smile, composing herself. 'I do not like giving orders, especially to such liberal-minded people, but I will give you some advice and add a request.'

Tutor: 'Your request shall be our command.'

Baroness: 'It would be foolish of me to imagine I could divert the interest everyone takes in the great events, to which we ourselves have unfortunately fallen victim. I cannot change the opinions which form within each, according to his outlook, take root and strive to make themselves felt, and it would be as foolish as it would be cruel to demand that you should not express them. But what I can expect from the circle in which I live is that you should quietly seek out like-minded companions and enjoy conversations in which the one says what the other already thinks. In your rooms, out on walks, wherever those who agree with each other meet, you can unburden yourselves to your heart's content, support this or that opinion, enjoy the pleasure of expressing a passionately held conviction. But, dear friends, when we are together let us not forget how much of our individuality we had to sacrifice to be sociable

even before there were all these matters to talk
about, and that as long as the world still stands
everyone will have to keep themselves under control,
at least outwardly, if they want to be sociable. So it is
not in the name of morality, but of common cour-
tesy that I call on you to behave at such times
towards me and others as you have behaved, from the
days of your youth onwards, I think I may say,
towards anyone you met in the street.

'I just do not understand what has happened to
us,' the Baroness went on, 'where all our social
decorum has suddenly gone. In society people used to
take great care not to touch on matters which some-
one else might find unpleasant. In the presence of
Catholics, a Protestant would avoid making fun of
any ceremony, and even the most zealous of Catholics
would not hint to a Protestant that the old religion
offered greater certainty of eternal salvation. One
avoided talking about what a delight one's children
were, when there was a mother in the company who
had lost her son, and one felt embarrassed if one let
slip an inadvertent remark like that; everyone there
would try to make up for the lapse. And is not what
we have been doing here precisely the opposite of
that? We have actually been seeking out any
opportunity to say something that annoys the one
we are talking to and makes him lose his equanimity.
O my friends, let us return to our former mode of
behaviour. We have already been through enough sad
experiences – and soon, perhaps, the smoke by day
and flames by night will signal the destruction of our
homes and the property we left behind. Let us not

allow that news to arouse passions within our company again; it will cause us enough pain within our hearts, let us not increase it by frequent public repetition.

'When your father died, did you, by word or gesture, remind me of that irreparable loss on every occasion that presented itself? Did you not try to do everything to avoid bringing back his memory at the wrong time and to soothe the feeling of loss and to heal the wound with your love, your silent endeavours, your kindheartedness? Is it not now more than ever necessary for us all to practise that forbearance which is often more effective than well-meaning but crude help? Now, at a time when it is not a matter of one or other of us, in the midst of more fortunate friends, being brought down by some mischance, which is quickly absorbed in the general sense of well-being, but when, among a huge number of unfortunates there are at most a few who, either through nature or upbringing, either by chance or design, enjoy a contented existence?'

Karl: 'You have shamed us enough, dear Aunt, will you not offer us the hand of friendship once more?'

Baroness: 'Here is it, on condition you will allow yourselves to be guided by me. Let us call a truce, it cannot come soon enough.'

At this point the other women, who, after taking leave of their friends, had alleviated their sorrow with tears, came in. The looks they gave Karl were far from friendly.

'Come and join us,' cried the Baroness. 'We have just had a serious discussion which, I hope, will

restore peace and harmony among us, and the
decorum that has been missing for a while. Perhaps it
has never been more needful for us to come together
and amuse each other, even if only for a few hours
each day. Let us come to an agreement that when we
are gathered together we will ban all conversation on
matters of topical interest. How long we have had to
do without instructive and stimulating discussions!
How long it is since you, dear Karl, told us about
distant countries, about whose situation, inhabit-
ants, customs and traditions you know so much. And
how long it is since you' – she was addressing the
tutor – 'talked about ancient and modern history,
comparing different centuries and historical figures.
What has happened to those lovely, elegant poems
which so often used to appear from our young ladies'
pocket-books to delight the company? What has
happened to those free-ranging philosophical reflec-
tions? Have you completely lost the pleasure you
used to take in bringing back from your walks an
unusual stone, an unknown plant – at least to us – a
strange insect, which gave us the opportunity of
pleasant dreams, if nothing more, of the grand
design uniting all creatures. Let us make an agree-
ment, a resolution, a rule to resume all these amuse-
ments, which used to arise so spontaneously, to make
every effort to be instructive, useful and, especially,
sociable, for we shall need to be all of that, far more
than now, even if everything should collapse around
us. Promise me that, my friends.'

They promised with alacrity.

'Go now; it is a fine evening, let everyone enjoy it in

his own way. And at dinner let us enjoy, for the first time in a long while, the delights of friendly conversation.'

At that the company dispersed. Only Fräulein Luise stayed sitting with her mother; she could not so easily put her vexation at losing her companion behind her and gave Karl, who invited her out for a walk, a very tart response. Thus mother and daughter had been sitting together in silence for a while when the priest came in; he was returning from a long walk and so had heard nothing of what had happened in the meantime. He put his hat and stick away, sat down and was about to speak when Fräulein Luise, as if she were continuing a conversation she was having with her mother, cut him short with the following words:

'Some people will find the rule that has just been agreed on pretty restrictive. Even before, when we lived in the country, we often lacked topics of conversation. It wasn't the same as in town, where every day there's a poor girl to defame, or a young man to cast aspersions on. But until now we've had the alternative of recounting silly stories about great nations, finding the French and the Germans ridiculous, making out this or that person was a Jacobin. If this source is cut off, then some people will presumably just sit there in silence.'

'Is that thrust aimed at me, Fräulein Luise?' the old man said with a smile. 'You know that I am happy to be an occasional butt for the rest of the company. While you are a credit to your excellent governess on every social occasion, and everyone

finds you pleasant, charming and agreeable, yet you seem to let a nasty little demon, that you have living inside you and cannot quite control, get his own back on me for the restraint you put on him. Tell me, Baroness,' he went on, turning to her mother, 'what has been going on in my absence? What kind of conversations are banned in our circle?'

The Baroness told him everything that had happened. He listened attentively, then said, 'In that arrangement it should not be impossible for some people to amuse the company, perhaps better and more surely than others.'

'We'll believe it when we see it!' said Luise.

'This rule,' the priest continued, 'will not be a burden to a person who knows how to keep his mind occupied. On the contrary, he will enjoy presenting in public things with which he normally occupies himself in private. Don't take this amiss, Fräulein, but who is it that creates the scandalmongers, the caustic tongues, the prying eyes but society? I have seldom seen a group of people as attentive, their minds as active at a reading dealing with a topic of interest to the heart and the mind, as when listening to some titbit of news, especially one that shows up someone they know in a bad light. Ask yourself, ask others: what is it that makes the appeal of any occurrence? Not its importance, not its influence, but its novelty. Normally it is only what is new that seems important because it arouses our curiosity without reference to the wider context, stimulates our imagination for a moment, barely touches our emotions and does not tax our minds at all. Any person can take a lively

interest in what is new without the least exertion of
their faculties; indeed, since we get carried along by
the flow of news, nothing is more welcome to the
great mass of people than the endless diversion of a
series of stories which give them an easy and
repeated opportunity to express their spite and their
malice.'

'Well!' cried Luise. 'You certainly had no difficulty
solving that problem. It used to be individuals who
were pulled to pieces, now it's the whole human race
that's in for it.'

'I do not ask that you judge me fairly,' he replied,
'but I will say this much. We who are dependent on
society have to mould and adapt ourselves to it, and
it is easier for us to do something contrary to society
than something it finds tedious. And there is nothing
in the world it finds more tedious than being required
to think, to reflect. One must avoid everything that
does that; at most we can go through for ourselves in
private what is barred in any public gathering.'

'What you'll have been through at most in private
will have been a few bottles of wine,' Luise retorted,
'and you'll have slept through some of the best hours
of the day.'

'I have never regarded what I do as especially
valuable,' the old priest went on, 'and I know that
compared with others I am an idler. But I have
assembled a collection which might provide, if not
the best, then at least some pleasant hours for this
present company, given its mood.'

'What kind of collection is that?' the Baroness
asked.

'Nothing more than a compendium of tittle-tattle, I'm sure,' Luise declared.

'You are wrong,' the priest said.

'We shall see,' Luise replied.

'Let him finish,' said the Baroness. 'And, anyway, I do not like to hear you using that sharp, unfriendly tone, even to a man who may take it as a joke. We should not give encouragement to the bad habits we possess, even in jest. Tell me, my friend, what does your collection consist of? Will it serve to entertain us? Is it suitable for that? Why have we not heard of it before?'

'I will explain that,' said the old priest. 'I have lived in this world for a long time and have always been interested in the things that happen to different people. I feel I have neither the strength nor the confidence to attempt an overall view of history, and the individual events on the world stage just confuse me. But among all the personal stories, true and false, that people concern themselves with, that they tell each other in private, there are some whose attraction is purer, finer that the attraction of mere novelty. There are those that would amuse us with a witty twist; some give us a momentary insight into the inner workings of human nature, others delight us with their bizarre absurdities. From among the great mass of stories which commonly engage our attention and our malice, and which are as common as the people you meet or who tell them, I have collected those which touched my heart or occupied my mind and which, when I thought back to them, gave me for a few moments a sense of pure, serene calm.'

'I am very curious to hear what kind of stories these are,' said the Baroness, 'and what they actually deal with.'

'As you can well imagine,' the old man replied, 'court cases and family affairs do not crop up very often. Those are usually only of interest to the people who are affected by them.'

Luise: 'So what do they contain, then?'

Priest: 'I cannot deny that they usually deal with the emotions that bind men and women together or set them apart, make them happy or unhappy, more often confuse rather than enlighten them.'

Luise: 'Really? So it's probably a collection of lascivious pranks you're putting out as elegant entertainment? Forgive my remark, Mama, but it seems so obvious and surely one may speak the truth?'

Priest: 'You will, I hope, find nothing in the whole collection of what I would call lascivious.'

Luise: 'And what do you call lascivious?'

Priest: 'I find a lascivious conversation, a lascivious story unbearable. They present something common, something which is not worth talking about, not worth bothering with, as something special, charming, and arouse false desire instead of occupying the mind in a pleasant manner. They cast a veil over things which one should either see unveiled or not at all.'

Luise: 'I don't understand. Surely your stories will be told with a certain elegance? Are we to be expected to put up with tasteless jokes? You're going to turn the house into a girls' school and expect us to thank you for it?'

Priest: 'Not a bit of it. In the first place, you will not learn anything new, especially since I have noticed that you do not skip over certain reviews in the newspapers.'

Luise: 'Now you're making suggestive remarks.'

Priest: 'You are engaged to be married, that is excuse enough for me. I just want to show that I, too, have barbs I can use against you.'

Baroness: 'I can see what you are getting at, but you have to make it clear to her.'

Priest: 'All I would do is to repeat what I said at the beginning of our discussion, but she appears to lack the good will to pay heed to it.'

Luise: 'All the fine talk, all the good will in the world will not change the fact that, however you look at it, the stories will be scandalous, scandalous in one way or another, and that's all.'

Priest: 'Must I repeat, Fräulein Luise, that to a right-thinking person things only appear scandalous when he sees malice, arrogance, the desire to hurt and unwillingness to help; and he looks away. Minor errors and shortcomings, on the other hand, he finds amusing, and he enjoys reflecting on stories in which he sees a good person in mild conflict with himself, his desires and principles; or ones in which fools, who have an exaggerated sense of their own importance, are tricked or shown the error of their ways; or others in which any presumption is punished in a natural way, by chance even, in which intentions, wishes and hopes are now obstructed, thwarted, disappointed, now unexpectedly realised, fulfilled, confirmed. He enjoys reflecting on cases where chance

plays with human weaknesses and inadequacies, and none of the heroes whose stories he collects has cause to worry about censure or expect praise from him.'

Baroness: 'That introduction makes one wish to hear a sample, and soon. I would not have thought that much had happened in our world – we have spent most of our time in a small circle of acquaintances – that could have been included in such a collection.'

Priest: 'Much depends on the observer and on what one can see in things, but I will not deny that I have taken some from old books and traditions. You will perhaps not be unhappy to find among them some old friends in a new garb; but that gives me one advantage I refuse to relinquish: you must not try to probe the truth behind any of my stories.'

Luise: 'Surely you can't stop us recognising our friends and neighbours and, if we like, deciphering the puzzle?'

Priest: 'Not in the least. But then you must allow me, in such a case, to bring out an ancient tome to prove that the story happened, or was made up, a few hundred years ago. Equally you will allow me a secret smile when a story which occurred in our immediate circle, but which is not recognised in this garb, is declared an old folk tale.'

Luise: 'It's impossible to pin you down. I think the best thing would be if we called a truce for this evening and you told us a little story to show us what you mean.'

Priest: 'You must allow me to disappoint you there. This entertainment is to be kept for the whole

company. We should not deprive them of any of this, but one thing I can tell you in advance: the stories I have to relate have no intrinsic value. If, however, the company, after some serious discussion, needs to relax for a while, if they have already eaten their fill of solid fare and are looking for a light dessert, then I will be ready, hoping that what I serve them will be judged not unappetising.'

Baroness: 'We shall just have to wait until tomorrow, then.'

Luise: 'I'm very curious to hear what he will tell us.'

Priest: 'You should not be, Fräulein. Keen expectation is seldom satisfied.'

In the evening after dinner the Baroness withdrew early to her room, but the others stayed up together talking about news that had just arrived and rumours that were going round. As was usual at such times, they were unsure what to believe and what not.

To that the old priest said, 'I think the best thing to do is to believe what we are happy with, simply reject what we are unhappy with and leave the truth to look after itself.'

Somebody remarked that that was what people usually did anyway and, after a few twists and turns, the conversation came round to our innate propensity to believe in the supernatural. They talked about romances and ghost stories, and when the old priest promised to tell them a few good tales of that kind at some future date, Fräulein Luise said, 'Since

we are in the right mood, you would be doing us a kindness to tell us one now; we would be extremely grateful.'

The priest did not need much pressing and started as follows:

'When I was staying in Naples I came across a story there which caused a great stir and great differences of opinion. Some claimed it was a complete invention, others that it was true, but that there was some deception behind it. The latter group were divided among themselves, arguing about who might have been deceiving whom. There were others who maintained that it was by no means certain that spiritual beings could not influence physical matter or bodies, and that not every strange occurrence had to be automatically declared a lie or a delusion. Now to the story itself.

'At that time there was a singer called Antonelli who was the darling of Naples. With youth, physical beauty and talent in abundance, she lacked nothing a young woman needs both to entice and attract the crowd, and to delight and rejoice a small circle of friends. She was not averse to praise and love; naturally moderate and sensible, she enjoyed the pleasures both provided without losing the composure so necessary in her situation. All the noble, rich young men flocked round her; she only accepted a few and if, in the choice of lovers, she mostly followed her heart and her eye, in all her little amours she showed a firm, dependable character of the kind to win the approval of any keen observer. I had the opportunity

of seeing her for a while as I was close to a man who enjoyed her favours.

'The years had passed and she had got to know plenty of men, among them many conceited fops, weak, unreliable characters. She had come to the conclusion that a lover, who in a certain sense is everything to a woman, mostly becomes as nothing in precisely those situations where she most needs support: when important events occur, when immediate decisions are required or domestic arrangements to be made; even more, he may harm his beloved by only thinking of himself and feeling himself impelled, out of selfishness, to advise her to follow the worst course of action and encourage her to take the most dangerous steps.

'Her relationships so far had mostly left her mind unoccupied; it, too, demanded nourishment. After all these years she wanted to have a *friend*, and hardly had she felt that need than a young man appeared among those approaching her in whom she immediately put her trust and who seemed entirely worthy of it.

'He was from Genoa; important business for his firm had brought him to Naples. Of a very cheerful disposition, he had had a most careful upbringing. His knowledge was extensive, both his mind and body perfectly developed; in his behaviour he could be taken as a model of a man who never forgets himself, yet seems to have the ability to enter into the feelings of others. He was imbued with the commercial spirit of his native city; he took the larger view of what needed to be done. Yet his situation

was not the happiest: his firm had engaged in some highly doubtful ventures and was involved in dangerous legal proceedings. With time the affairs had become even more tangled, and the worry this caused him gave him a touch of melancholy, which suited him very well and encouraged the young lady even more to seek his friendship, because she felt he was in need of a friend himself.

'Up to this point he had only seen her occasionally and in public places. Now, at his first request, she granted him entry to her house; indeed, she was most insistent in her invitation, which he did not fail to follow.

'She wasted no time in making him acquainted with her trust in him and her wish. He was surprised and delighted at her proposal. She beseeched him to remain her friend and not make any lover's demands. She described a difficulty in which she found herself at that time in which he, with his manifold connections, would be able to give her the best advice and show her the speediest way to turn things to her advantage. In return, he confided his own situation to her and, as she comforted him and cheered him up, some ideas developed in her presence which would otherwise not have come to him so soon, so that she appeared to be advising him as well. In no time at all a friendship had been established between them based on the highest respect and mutual need.

'Unfortunately, however, when we agree to conditions, we do not always reflect on whether they are feasible or not. He had promised to be simply her friend, not to claim the place of lover, and yet he

could not deny that he found the lovers who enjoyed her favour a nuisance, annoying, indeed, completely unbearable. What particularly pained him was to hear his friend talk wittily about the good and bad qualities of such a man, apparently well aware of all her lover's failings, and yet to know she would spend perhaps even that very same night, as if in mockery of the friend she respected so highly, in the arms of a man who was unworthy of her.

'Fortunately or unfortunately it happened soon afterwards that this place in the fair lady's affections fell free. Her friend observed this with delight and tried to convince her that he was the best person to fill the vacant position. She gave in to his wishes, but reluctantly and against her better judgment. "I fear," she said, "that by yielding thus I will lose the most valuable thing in the world: a friend."

'And her prophecy came true. He had not served her in this double capacity for more than a short while than his moods began to become more and more irksome. As a friend he demanded all her respect, as a lover all her affection and as an intelligent and pleasant man constant diversion. But this was not at all to the lively young woman's liking. She was not willing to make any sacrifices and had no desire to accord anyone exclusive rights. She tried gently, therefore, to reduce his visits little by little, to see him less frequently and to make him realise that she would not give up her freedom for anything in the world.

'As soon as he noticed this, he felt he had suffered the greatest misfortune imaginable. Unfortunately

this was not his only setback; the affairs of his firm
started to go extremely badly too. He reproached
himself that from his earliest youth he had regarded
his wealth as inexhaustible, that he had neglected his
business affairs so that on his travels he could cut a
nobler and richer figure in society than his birth and
income warranted. The court cases, on which all his
hopes rested, were slow and expensive. Because of
them he had to go to Palermo several times and dur-
ing his last absence the sensible young woman made
a number of changes to her domestic arrangements
in order to distance herself from him gradually. He
returned to find her in a different apartment, far
from his own, and saw that Marchese di S., who at
the time was an important figure in all public diver-
sions and entertainments, visited her regularly and
was clearly on intimate terms. This was too much for
him and he fell seriously ill. When news of this
reached his friend, she hurried to his side, cared for
him, arranged for attendants to look after him, and
when she realised that his finances were not in a
healthy state either, she left a considerable sum of
money with him, sufficient to relieve him of that
worry for some time.

'Through his presumption in trying to limit her
freedom, her friend had forfeited some of her good
opinion of him; as her affection for him grew less, so
her observation of him grew sharper. Finally, the dis-
covery that he had acted so unwisely in his own
affairs did not give her the most favourable impression
of his intelligence and his character.

'He, however, did not notice the great change that

had taken place within her. On the contrary, her concern for his recovery, her devotedness in spending half the day at his bedside, seemed to him more signs of friendship and love than of pity, and he hoped that once he had recovered he would be restored to his old position.

'How wrong he was! As his health returned and his strength revived, all her affection, all her feeling for him vanished, she found him as much of a burden as he had formerly been a pleasant companion. Also, during all that had happened he had become, without noticing it himself, extremely bitter and aggrieved. He put all the blame for his fate not on himself, but on others; he was very good at justifying himself in everything. He saw himself as a man who had been unjustly persecuted, offended, made to suffer and he hoped, once he was well again, to be fully compensated for all his ills, all his sufferings, by the complete submission of his mistress.

'He came out with these demands on one of the very first days when he could go out again and visit her. He asked nothing less than that she should submit to him completely, dismiss all her other friends and acquaintances, give up the stage and live with him and for him alone. She explained how impossible it was to agree to his demands, at first in a witty then in a serious manner, and was finally compelled to confess to him the sad truth that their relationship was at an end.

'He lived on for a few years as a recluse, his sole company being a pious old lady who shared his house and lived off the meagre income from her estates.

During that time he won first the one, then the other lawsuit; however, his health had been undermined and his heart's desire lost. A minor cause led to another serious illness; the doctor told him he was going to die. He accepted the verdict without recrimination, but his one wish was to see his friend again. He sent to her by his servant, who in happier days had often brought a favourable reply. He asked her to come; she refused. He sent again, beseeching her to come; she remained obdurate. Finally, it was late at night, he sent to her a third time; she was moved and confided her dilemma to me, as I happened to be dining with her, along with the Marchese and a few other friends. I gave her my advice, suggesting she do her friend this one last kindness; she seemed undecided, but, after some reflection, came to a decision. She sent the servant away with a negative answer and he did not come back again.

'After dinner we sat round chatting together; we were all cheerful, in good spirits. It was close on midnight when, suddenly, a piercing, mournful, fear-stricken voice was heard that reechoed for a long time. We all started, looked at each other, looked round, wondering what this was going to lead to. The voice seemed to come from the middle of the room and die away at the walls. The Marchese leapt up and dashed over to the window, the rest of us looked to our hostess, who was lying there in a faint. She only came to gradually. Hardly had she opened her eyes than the jealous and passionate Italian started to reproach her bitterly. "If you must arrange signals with your friends," he said, "then at least make

them less striking and strident." With her usual presence of mind, she replied that, since she had the right to receive anyone at any time in her house, she was hardly likely to choose such terrible and doleful sounds as a prelude to spending time in pleasant company.

'The voice certainly had something terrifying about it. The echo was still reverberating in our ears, in our limbs even. The singer was pale, still close to fainting, we had to stay with her half the night. Nothing more was heard. The next night, the same company, not so cheerful as the previous evening, but calm enough – and the same ghastly, deafening sound at the same time.

'In the meanwhile we had entertained countless theories about the nature of the cry and where it might have come from, and our conjectures were exhausted. To cut a long story short, every time she dined at home it could be heard at the same hour, sometimes louder, people maintained, sometimes quieter. The whole of Naples was talking about it. All the people who lived in the building, all her friends and acquaintances were most concerned, the police were even called in. Lookouts and observers were installed. To those out in the street, the cry seemed to come from the open air, while in the room it similarly sounded as if it came from close by. Whenever she dined out, nothing was heard; whenever she was at home, the cry rang out.

'But even away from home she was not entirely free from her malevolent shadow. Her charm had gained her invitations from the best families, she was

good company and was welcome everywhere, so in order to avoid her disagreeable guest, she had got into the habit of spending her evenings out.

'One evening a man, venerable in both age and position, was taking her home in his carriage. While she was saying farewell to him at her door, the sound suddenly arose between them and the man, who was as well acquainted with the story as any other, had to be lifted back into his carriage, more dead than alive.

'Another time a young tenor she was fond of was driving through the town with her to visit a friend. He had heard people talk of this strange sound but, being a bright young man, had his doubts about such supernatural phenomena. They talked about it. "I would very much like to hear the voice of your invisible companion," he said. "Why don't you call him up, there are two of us here, there's no need to be afraid."

'What it was that impelled her, boldness or thoughtlessness, I could not say, but she called on the spirit and in an instant the blaring noise was there, right in the middle of the carriage. Three times in rapid succession it rang out like a clap of thunder, then died away in a frightening diminuendo. The two of them were found, outside the friend's house, unconscious in the carriage. It was only with difficulty that they were brought round and could tell people what had happened.

'It took some time for the fair singer to get over it. This repeated terror was beginning to affect her health, and the ghostly voice seemed to grant her some respite. Indeed, since it had not made

itself heard for a long time, she even hoped she was completely free of it. Her hope, however, was premature.

'After the carnival was over she went on a short trip with a woman friend and a maid to visit some people who lived out in the country. They were not due to arrive until after dark but, since there was something wrong with their carriage, they had to spend the night in an inferior inn and make themselves as comfortable as they could.

'Her friend was already in bed and the maid had just lit the night-light and was about to go to bed too, when the singer, joking, said, "It's the back of beyond here and the weather's dreadful, I wonder if he can find us?" Immediately the sound rang out, louder and more terrible than ever. Her friend was convinced all hell had been let loose in the room, leapt out of bed and ran down the stairs, dressed only in her nightgown, and woke the whole house. That night no one slept a wink. But it was the last time the sound was heard. Unfortunately the uninvited guest had soon found another, even more irksome way of announcing his presence.

'It had left her in peace for some time when, one evening at the usual time, while she was dining with her guests, a shot, as if from a rifle or a heavily charged pistol, came in through the window. They all heard the report, they all saw the flame, but on closer inspection it turned out that the windowpane was completely undamaged. Despite that, they took the incident very seriously and they all assumed someone was out to kill the fair singer. They rushed to the

police, they searched the neighbouring houses and, since they found nothing suspicious, the next day they placed guards in them from top to bottom; they subjected the house where she lived to a thorough search and posted lookouts in the street.

'All these precautions proved vain. For three months the shot was fired at the same moment, through the same window, without damaging the glass. What was even more strange was that it was always at precisely one hour before midnight, yet usually in Naples they go by Italian time in which midnight is not important.

'Eventually they got used to the phenomenon, as they had to the previous one, and did not think much of the ghost's harmless malice. Sometimes the shot did not even startle the company or interrupt their conversation.

'One evening, after a very warm day, the singer opened the window, without thinking what time it was, and stepped out onto the balcony with the Marchese. They had hardly been out there for a few minutes than the shot fell between the two of them, hurling them back forcibly into the room, where they tumbled to the floor, unconscious. When they had come to again, his left and her right cheek ached, as if they had been given a hefty slap. Since they had no other injuries, the incident gave rise to a number of jocular remarks.

'From that time on the gunshot was not heard in the house again and she thought she was finally free of her invisible persecutor when, one evening as she was on her way to visit a woman friend, she received

a violent shock from an unexpected occurrence. Her route took her along Via Chiaia, where her Genoese friend and lover had lived. It was bright moonlight. A lady who was in the carriage with her, asked, "Is that not the house where Signor * * * died?" – "As far as I know, it is one of those two," the singer said, and at that moment a shot rang out from one of the two houses and passed through the carriage. The coachman thought they were being attacked and drove off as quickly as possible. When they reached their destination, the two women were taken for dead and had to be carried into the house.

'But that fright was the last. Her invisible companion changed his method and a few evenings later loud clapping could be heard outside the house where she lived. It was a sound she, as a popular singer and actress, was accustomed to, there was nothing frightening about it, it could have been one of her admirers. She paid it little attention, but her friends were more curious and, as before, posted lookouts. They heard the noise, but, again, could not see anyone. Most hoped it meant there would soon be an end to these phenomena.

'After a while this noise also disappeared and turned into more pleasant sounds. They did not make an actual melody, but they were uncommonly sweet and pleasant. To those who observed them most closely, they seemed to emanate from the corner of a side street and float up through the empty air to her window, where they would fade away with a soft, dying fall. It was like a beautiful prelude with which a heavenly spirit was drawing attention to

the melody it was about to play. This sound, too, eventually disappeared, never to be heard again. The whole, strange affair had lasted about a year and a half.'

When the narrator paused here for a moment, the company immediately started to express their thoughts and doubts about the story, whether it was true, whether it could be true?

The old priest maintained it had to be true if it was to be interesting; it had little merit, he said, as an invented story. At that someone remarked that it seemed strange no one had thought fit to find out about the friend who had died and the circumstances of his death, because that might perhaps have been able to supply some explanation for the story.

'That did happen,' the old priest said. 'I myself was sufficiently intrigued to go to his house after the first visitation, on the pretence of going to see the lady who, as his end approached, had looked after him with motherly care. She told me her friend had harboured an extreme passion for the young singer, that during his last days he had spoken almost exclusively of her, sometimes seeing her as an angel, sometimes as a fiend. When there was no hope of recovery from his illness, his only wish had been to see her one last time, presumably hoping to move her to a tender word, an expression of remorse or some other sign of love and friendship. Her continued refusal had been all the more terrible for him and her final "no" had visibly hastened his end. In despair, she said, he had cried out, "No, that will not save her. She refuses to come to me, but even after my death I

56

will not leave her in peace." On that violent note he
died and, she concluded, we have learnt only too well
that people can keep their word even from beyond
the grave.'

Once more everyone started giving their opinions
and judgments on the story. Finally Luise's brother
Friedrich said, 'I have a suspicion, but I am loth to
express it before I have brought all the circumstances
back to mind and checked over my deductions more
thoroughly.'

When they started to press him more insistently,
he tried to get out of giving an answer by offering to
tell a story himself which, though not as interesting
as the previous one, was another of those that one
could never explain with complete certainty.

'An orphan, a girl, had been brought up in the house
of a friend of mine, an honest nobleman with a large
family. Once she was grown up, from her fourteenth
year onwards, she was mostly occupied as a personal
servant attending to the needs of the lady of the
house. They were satisfied with her and she seemed
to wish nothing more than to be able to show her
gratitude to her patrons by loyal and attentive ser-
vice. She was attractive and a few suitors appeared.
It was not felt, however, that any of these proposed
unions was of the kind to ensure her happiness and
she did not show the least desire to change her state.

'Suddenly it happened that whenever the girl went
round the house about her business, a knocking could
be heard here and there below where she was. At first
people joked about it, but eventually it started to

become a nuisance. The master of the house, who was of an inquiring mind, investigated the matter himself. The knocking was not heard until the girl started to move, and it did not come as she placed her foot on the floor but as she lifted it for the next step. Sometimes the sounds were irregular and they were particularly loud when she crossed the great hall.

'One day, when the knocking was as loud as it had ever been and there happened to be workmen nearby, my friend had a few floorboards taken up immediately behind her. Nothing was found apart from a few large rats which appeared and were hunted down with a great furore.

'Indignant at the affair and the commotion it caused, the master of the house turned to sterner measures, took down his largest hunting whip and swore he would thrash the girl to within an inch of her life if the knocking were heard one more time. From then on she went round the whole house without disturbance and the knocking was not heard again.'

'Which only goes to show,' Luise broke in, 'that the pretty girl was her own ghost and for some reason or other had thought to play this prank on her benefactors.'

'Not at all,' Friedrich replied. 'Those who attributed the phenomenon to a ghost believed that some guardian spirit wanted to get the girl out of the house, but did not want to harm her. Others took a different view and thought one of her lovers had the knowledge or skill to create these sounds and was using them to force the girl out of the house and into his arms. Be that as it may, the poor child wasted

almost completely away because of the affair and looked like a melancholy ghost where once she had been bright and lively, the most cheerful person in the whole house. But there can be more than one explanation for that kind of physical decline.'

'It's a pity,' said Karl, 'that such incidents are not subjected to a proper investigation. In judging these events, which we find interesting, we are always left wavering between various possibilities because not all the circumstances surrounding these strange events have been noted.'

'If only such an investigation were not so difficult,' said the priest. 'If only, at the moment such an event occurs, we could be aware of all the crucial points and factors, so that we did not miss anything where error or deception might lie concealed. But can we even spot a conjuror's sleight of hand, where we know he is trying to trick us?'

Hardly had he finished than a loud bang was heard from the corner of the room. Everyone started and Karl said jokingly, 'That can't be a dying lover making himself heard, can it?'

He wished he could have taken his words back. Luise had turned pale and confessed that she feared for the life of her fiancé.

In order to take her mind off such thoughts, Friedrich picked up a candle and went over to the desk in that corner. Its curved top had a crack right across it. That explained the noise, but still it seemed odd that this desk, one of Röntgen's best pieces, which had stood in the same place for several years, should happen to crack at that precise moment. It

had often been pointed out as a model example of excellent and lasting workmanship, and now it suddenly split without the least change in the atmosphere being perceptible.

'Quick,' said Karl, 'let us check the barometer and establish that factor.'

The mercury was at the same level it had been for the last few days; even the thermometer had fallen no more than was natural for the transition from day to night.

'Pity we haven't got a hygrometer to hand,' he exclaimed, '*that*'s the instrument we need most.'

'The most necessary instruments always seem to be the ones we lack when we are investigating ghosts,' the priest said.

Their discussion was interrupted by a servant rushing in to announce that there was a great fire to be seen in the sky, though no one could say whether it was in the town or in the surrounding countryside.

The preceding events had made them more receptive to terror and everyone was more affected by the news than they might otherwise have been. Friedrich hurried out onto the terrace, where a detailed map of the area had been engraved on a horizontal disc. With its help it was possible to determine the positions of the various places with a fair degree of accuracy. The rest of the company, prey to a certain amount of concern and agitation, stayed together.

Friedrich returned and said, 'The news is not good. It is most likely that the fire is not in the town but on our aunt's estate. I know the land in that direction very well and I fear I am not mistaken.'

The company expressed their regrets at the fine buildings that were lost and worked out the cost. 'However,' said Friedrich, 'I have just had a rather odd idea which might at least reassure us as far as the strange omen of the desk is concerned. Above all we must determine the precise time when we heard the noise.'

Working back, they decided it would have been at around half past eleven.

'Now you may laugh,' Friedrich went on, 'but I will tell you my hypothesis. As you know, several years ago our mother gave our aunt a similar desk. Both were made with the greatest care at the *same* time, from the *same* wood, by the *same* craftsman. Until now both have survived in good condition, but I am willing to bet that at that moment our aunt's desk was consumed by fire in her summerhouse and that its twin is suffering in sympathy. I will go over myself tomorrow and verify this strange fact as far as possible.'

Whether Friedrich really believed this, or whether he had just thought it up to calm his sister, we cannot say, but it did lead to a discussion of some sympathetic reactions which were an indisputable fact, with the result that they came to see sympathy between pieces of wood that had grown in the same trunk, between objects made by the same craftsman as not unlikely. Indeed, they agreed that such events should be counted as natural phenomena as much as other, more frequent ones, that are obvious yet still cannot be explained.

'It seems to me,' said Karl, 'that it is the phenomenon, the fact in itself, which is interesting. People

who explain it, or relate it to other phenomena, such as those who investigate natural or human history, usually do so for their own amusement and pull the wool over our eyes. But an individual action or event is interesting, not because it can be explained or is probable, but because it is true. If our aunt's desk was consumed by fire just before midnight, then the strange split that appeared in ours at the same time is for us a true happening, whether it's explicable and related to others or not.'

Despite the fact that it was already very late, no one felt inclined to retire to bed, and Karl offered to tell a story of his own, which, he claimed, was no less interesting, even though it was perhaps easier to explain and understand, than the previous ones.

'Marshal Bassompierre,' he said, 'tells the story in his memoirs. If you will permit, I will recount it as if he were speaking himself:

'For the last five or six months I had noticed that whenever I crossed the little bridge – at that time the Pont neuf had not yet been built – a beautiful shop-keeper, whose shop had the sign of two angels, would bow low to me several times and watch me ride on for as long as she could. I was struck by her behaviour and looked at her and was assiduous in returning her greeting. Once, as I was riding back from Fontaineb-leau to Paris, when I came to the little bridge she appeared in the doorway of her shop and said, as I rode past, "Your servant, sir." I replied and, turning round from time to time, saw that she kept leaning forward to watch me for as long as possible.

'Following me were a servant and a postillion, whom I intended to send back that same evening with letters to several ladies in Fontainebleau. On my order the servant dismounted and went to the young woman to tell her, in my name, that I had noticed how she liked to see me and greet me; if she wished closer acquaintance, I would be happy to come and see her at whatever she suggested.

'She replied that the servant could not have brought her more welcome news. She would be happy to meet me wherever I suggested, her only condition being that she could spend a night under the *same* blanket with me.

'I accepted her suggestion and asked my servant if he didn't know of a place where we could meet. He replied that he would take her to the house of a certain bawd. He advised me, however, since the plague had appeared here and there, to have the mattress, blankets and sheets sent over from my own house. I agreed to this and he promised to make a good bed for me.

'That evening I went there and found a very beautiful woman of about twenty dressed in an elegant nightcap, a shift of very fine material and a short, green, woollen skirt. She had slippers on her feet and had wrapped herself in a kind of peignoir. I found her exceptionally attractive and attempted to take a few liberties, but she politely rejected my caresses, demanding that we meet between the sheets. I acceded to her request and I can say that I have never known a more delightful woman, nor one who has given me greater pleasure. The next morning I

asked if I could see her again, as I was not due to
leave until Sunday; it was the Thursday night that
we had spent together.

'She replied that she desired it even more keenly
than I did, but if I was not staying there for the
Sunday it would be impossible since she could only
see me on the Sunday night. When I started to raise
difficulties, she said, "I can see that at the moment
you're tired of me and you want to leave on Sunday;
but you will soon think of me again and be happy to
stay one more day to spend the night with me."

'I was easily persuaded and promised to stay for
the Sunday and come to the same place for the night.
To that she said, "I know well, sir, that I have come
to a house of ill-repute for your sake, but I did it of
my own free will. I have such an irresistible desire to
be with you that I would have accepted any condi-
tions. My passion has brought me to this vile place,
but I would consider myself a whore if I were to
return a second time. May I die a most miserable
death if I have ever let any man have his way with
me apart from my husband and yourself, or desired
any other man. But what would one not do for a
person one loves, and for a Bassompierre? It is for his
sake that I have come to this house, for the sake of a
man whose very presence makes this place honour-
able. If you want to see me again, I will let you into
my aunt's house."

'She described the house most precisely and went
on, "I'll expect you between ten and midnight; even
later the door will still be open. First you come to a
short corridor, don't stop there, the door of my

aunt's room gives onto it. Then you will find a stair-case that leads up to the first floor, where I will receive you with open arms."

'I made my arrangements, sent my people and my things on ahead and waited impatiently for Sunday night, when I would see the beautiful young woman again. I was there at ten o'clock. I found the door she had told me about straight away, but it was locked and there were lights on everywhere in the house, from time to time they even seemed to blaze up like a fire. Impatient, I started to knock to announce my arrival, but it was a man's voice I heard, asking me who I was.

'I left and walked up and down the streets for while. Finally my desire took me back to the door, which I found open. I hurried along the corridor and up the stairs. But imagine my astonishment when I saw some people burning the straw from mattresses and, in the light of the fire, which illuminated the whole room, two naked bodies stretched out on the table. I hastily withdrew. As I was leaving, I ran into some gravediggers, who asked me what I was doing there. I drew my dagger, to make them keep their distance, and made my way home, not unmoved by the experi-ence. Once there I immediately drank three or four glasses of wine, which in Germany has been found to be effective in preventing the plague, had a good sleep, then set off for Lorraine the next morning.

'All my efforts, on my return, to find out some-thing about the woman were vain. I even went to the shop at the sign of the two angels, but the tenants did not know who had had it before.

'This affair was with a person of low degree, but I assure you that, had it not been for the unpleasant conclusion, it would have been one of the most delightful I can remember; I have never been able to think of the beautiful young woman without longing.'

'This puzzle is not that easy to solve, either,' said Friedrich. 'It is impossible to say whether the charming young woman died of the plague in the house, or whether she had simply avoided it because of the contagion.'

'Had she been alive,' said Karl, 'she would surely have waited for her lover out in the street; no danger would have kept her from going to see him again. I'm afraid she was one of the two bodies on the table.'

'That's enough!' said Luise. 'The story's just too horrible. What kind of night are we going to have, if we go to bed with images like that in our minds?'

'Another story has just occurred to me,' said Karl, 'which is pleasanter and which Bassompierre tells about one of his forebears:

'A beautiful woman, whom his ancestor loved to an exceptional degree, used to visit him every Monday in his summerhouse, where he would spend the night with her, telling his wife he had decided to make that the time when he would go out hunting.

'They had been seeing each other in this way uninterruptedly for two years, when his wife, beginning to grow suspicious, crept out to the summerhouse one morning and found her husband fast asleep with the other woman. Having neither the

66

courage nor the desire to wake them, she took off her veil and spread it over the feet of the sleeping couple.

'When the woman woke and saw the veil, she shrieked and broke out into a loud complaint, bewailing the fact that she would not be able to see her lover again, that she could not even come within a hundred miles of him. She left him, after she had given him a gift for each of his three legitimate daughters – a small fruit bowl, a ring and a goblet – telling him to take great care of them. They were very carefully looked after, and the descendants of his three daughters believed the cause of much of their good fortune lay in the possession of the three gifts.'

'That sounds more like the story of Fair Melusine and other fairy tales like that,' said Luise.

'Yet our family has a similar tradition and a similar talisman,' said Friedrich.

'What would that be?' Karl asked.

'It is a secret,' Friedrich replied. 'Only the eldest son is allowed to be told it while his father is still alive and take possession of the jewel after his death.'

'So it's in your keeping?' Luise asked.

'I think I have said too much already,' was Friedrich's answer, as he lit the candle to go off to bed.

The family had, as usual, breakfasted together and the Baroness was sitting at her embroidery once more. After a short, general silence, the priest said with a smile, 'It is rare that singers, poets or storytellers, when they promise to entertain a company, do so at the right time. Usually when they ought to come forward willingly, they take a lot of persuading,

and are insistent when one would rather not hear them. I hope, however, to be an exception to this rule if I ask whether at the moment you feel like hearing a story?'

'Very much,' said the Baroness, 'and I believe everyone else will agree with me. But if you are going to give us a story, then I must tell you which type I do *not* like. I do not enjoy those stories where, on the model of the *Arabian Nights*, one event is inserted within another, one theme ousted by another, where the narrator feels compelled not to satisfy our curiosity, which he has aroused in an irresponsible manner, but to titillate it by breaking off, not to fulfil our expectations with a logical sequence of events, but to create suspense with strange narrative devices which are not at all to be admired. I disapprove of this desire to turn stories, which should approach the unity of a poem, into disjointed puzzles, to the ever greater detriment of good taste. I leave it entirely up to you to select the subject of your story, but at least let the form show us that we are in polite society. To start with, give us a story with a limited number of characters and events, with a good idea and well thought-out, true, natural and not vulgar; a story with as much action as is required, as much reflection as is needed, which does not drag, does not get stuck on *one* spot, but does not rush along too quickly either; as story with characters we like to see, not perfect, but good, not exceptional, but interesting and pleasant. Let your story entertain us while we are listening to it, satisfy us when it ends and leave us with an urge to continue reflecting on it.'

'If I did not know you better, Baroness,' the priest replied, 'I would think these great and strict demands were intended to discredit my whole stock of tales, even before I had produced any of them. How rarely will people be able to satisfy you with those high standards. Even now,' he said, after he had thought for a while, 'you compel me to withdraw the story I had in mind and keep it for another time. And I really cannot say whether, in my haste, I am not making a mistake in launching straight into an old story, which I have always thought of as one of my favourites, and telling it extempore:

'In an Italian seaport there lived a merchant who, from his earliest days, had shown himself to be both energetic and shrewd. He was a good sailor into the bargain and had acquired great wealth by taking his ship to Alexandria himself, buying or exchanging costly wares, which he then sold at home or dispatched to the northern areas of Europe. His fortune grew from year to year, especially since his trading activities were his greatest pleasure and left him no time for expensive amusements.

'He had continued on his busy way until he reached the age of fifty. He had little experience of the social amusements which are the spice of life for more leisured citizens, nor, for all the attractions of Italian women, had the fair sex drawn his attention, except insofar as he was very well aware of their lust for jewellery and fine things, and exploited it now and then.

'Thus he was almost completely unprepared for

the change in his feelings when his richly laden ship entered the harbour of his home town on the day of an annual festival which was particularly designed for the children. After mass, boys and girls would go round dressed up in all kinds of disguises, in processions, in swarms, getting up to tricks all over the town, then playing various games in a large open field, showing off their gymnastic skills and competing in delightful races for small prizes.

'At first our mariner watched the celebrations with pleasure. However, after he had spent a long time observing the children's high spirits and their parents' delight in them, seeing so many people enjoying present pleasure and the most agreeable of all hopes for the future, he could not help, when he thought of himself, being struck by his solitary state. For the first time his empty house began to fill him with disquiet and he silently reproached himself.

' "Oh what an unfortunate wretch I am! Why have my eyes been opened so late? Why must I wait until old age is upon me to realise what are the only possessions that can make a person happy? All my labours, all the dangers I have faced, what have they brought me? My storehouses may be full of goods, my chests full of precious metals, my cupboards full of jewellery and precious stones, but these possessions can neither make me happy, nor satisfy my soul. The more I pile up, the more companions they seem to insist on: one stone demands another, one gold coin another. They do not recognise me as their master, they shout at me rudely, "Off you go, hurry up and bring more of us." Gold delights in gold

alone, jewels in jewels. They have been ordering me about like that for the whole of my life, and it is only now that I realise that all these things give me no joy. Only now, unfortunately, when I am already growing old, have I started to think and tell myself: you do not enjoy these treasures and no on who comes after you will enjoy them. Have you ever used them to adorn a woman you loved? Have you given them to a daughter as her dowry? Have you put a son in a position to win and keep the affection of a nice girl? No! Of all your possessions neither you, nor anyone of yours has possessed anything, and after your death the wealth you have assembled so laboriously will be frittered away by a stranger.

‘ "Oh how different are those fortunate parents who will gather their children round the table this evening, praise their skill and encourage them to be good. How their eyes shone with joy, how the present seemed bursting with hope for the future! Must you then remain barren of hope? Are you an old man already? Is it not enough that you realise what you are missing, that it is not yet too late? No, it is not foolish to think of taking a wife at your age. With your wealth, you will acquire a good wife and make her happy, and if your house should be blessed with children, those late fruits will give you the greatest pleasure instead, as so often happens with those to whom Heaven sends them too early, of being a burden they cannot cope with."

‘Having thus talked to himself into carrying out his intention, he sent for the two sailors who formed his regular crew and told them his idea. They, who

were accustomed to carry out his bidding promptly, were not remiss in this either and hurried off into the town to seek out the youngest and most beautiful maidens. If that was what their master had taken a fancy to, then only the best was good enough.

'He, too, was as busy as his emissaries. He went, asked, saw and listened, and soon found what he was looking for in a young woman who fully deserved her reputation as the most beautiful in the town at that time. She was sixteen years old, well-formed and well brought up; both her external appearance and her inner disposition were already most pleasant and boded well for the future.

'After brief negotiations, which guaranteed the fair maid a very comfortable situation both during the man's lifetime and after his death, the wedding was celebrated with great splendour and great joy, and from that day on the merchant felt for the first time that he truly possessed and enjoyed his wealth. Now it was his delight to use his finest and most sumptuous materials to clothe her beautiful body, his precious stones had a quite different lustre on the breast and in the hair of his beloved than formerly in his jewellery casket and the value of his rings was increased beyond measure by the hand that wore them.

'He felt not simply as rich, but richer than before, since sharing and using his possessions seemed to increase them, and for almost a year the couple lived perfectly content. He seemed completely transformed, having exchanged his love of an active life, always travelling around, for a feeling of domestic

bliss. But it is not so easy to divest oneself of an old habit, and a course we have taken from our early years can be diverted for a while but never entirely broken off.

'Thus when he saw others take ship or return safely to the harbour, the merchant quite often felt the stirrings of his old passion again; even in his own house, at the side of his wife, he sometimes felt restless and discontented. This desire increased with time, eventually turning into such a longing he became unhappy and, finally, fell ill.

' "What is going to become of you now?" he asked himself. "Now you see how foolish it is to exchange an old way of life for a new one when you are already well on in years. How can we clear the things we have always done, always sought, out of our minds, out of our limbs even? How do I feel, I who loved the water as much as a fish and the free air as much as a bird, now that I have shut myself up in a building with all my treasures and with that treasure beyond price, a beautiful young wife? Instead of the hoped-for content and enjoyment of my wealth, I feel I have lost everything by not acquiring more. It is wrong to consider those men fools who seek to pile up possessions on possessions; it is the activity which makes them happy, the wealth accumulated is unimportant for a man who knows the joys of uninterrupted endeavour. It is the lack of occupation that is making me miserable, the lack of activity making me ill, and if I do not resolve to make some change, I will soon be at death's door.

' "Of course it is a risk to go away and leave a

charming young wife at home. Is it right to woo an attractive and susceptible young woman and leave her after a short while to herself, a prey to boredom, to her feelings and desires? Are these young gentlemen in their silks not already promenading up and down outside my windows? Are they not already trying to attract the attention of my wife, in church and in the parks? What will it be like when I am not here? Should I let myself think my wife could be saved by a miracle? No, at her age and with her constitution it would be foolish to hope she could deny herself the pleasures of love. If you go away, when you return you will have forfeited your wife's affection and fidelity along with the family honour."

'These reflections and doubts, with which he tormented himself for some time, only made his condition more serious. His wife, his relatives and friends were worried about him without being able to discover the cause of his illness. Finally he thought things over again and after some reflection exclaimed, "Fool that you are to go to all these pains to keep a wife whom, if your malady progresses and you die, you will soon have to leave behind to another man anyway! Is it not better, or at least more sensible, to try to preserve your life, even if that means you are in danger of losing in her what is valued as a woman's greatest treasure? How many men are there who even by their presence cannot prevent the loss of that treasure and bear with patience the lack of what they cannot keep. Why should you not have the courage to part with such a treasure, since your life depends on taking that decision?"

'With that he pulled himself together and summoned his crew. He ordered them to load a vessel with the usual cargo and get everything ready so that they could put to sea with the first favourable wind. Then he explained his actions to hs wife in the following words:

' "Do not be disconcerted if you see a bustle about the house which tells you that I am preparing to go away on a journey. Do not be downhearted if I confess to you that I intend to go on another sea voyage. My love for you is the same as ever and will remain so for the rest of my life. I appreciate the happiness I have enjoyed at your side; it would be unalloyed if I did not silently reproach myself for my inactivity, my indolence. My old inclinations have reawakened, my old ways are drawing me back. Allow me to visit the market in Alexandria again; now my zeal will be all the greater because I intend to acquire the finest cloth and the most precious objects for you. I leave you in charge of all my possessions, all my wealth, make use of it and enjoy yourself with your parents and relatives. The time of separation will pass and our joy will be all the greater when we see each other again."

'There were tears in her eyes as the adorable woman reproached him tenderly, assuring him she would not be happy for a single hour without him; since she could not keep him, she said, nor wanted to tie him down, she only asked that during his absence he should think most kindly of her.

'He discussed various business matters and domestic arrangements with her then said, after a

pause, "There is one other thing I have on my mind; you must allow me speak freely about it. Only I beg you, from the bottom of my heart, not to misunderstand what I have to say, but to see my concern as another proof of my love for you."

' "I can guess what it is," his wife said. "You are concerned about me because, in the way of men, you believe our sex to be weak. You have known me as young and cheerful and now you think that in your absence I will be frivolous and easily seduced. I do not blame you for thinking like that, it is usual with you men, but as I know my heart, I can assure you that I am not easily impressed and nothing will make such a profound impression on me as to divert me from the path of love and duty. Put your mind at rest, when you return you will find your wife as tender and true as when you come to my arms after a brief absence."

"I believe you when you say that," her husband replied, "and I beg you to stick by it. But what if the worst should come to the worst, why should we not prepare ourselves for that? You know how your beauty and charms draw the glances of the young men of the town; when I am away they will pay you even more attention, they will try to approach you, to attract you. The thought of your husband will not always suffice, as my presence does at the moment, to keep them from your door and your heart. You are a good woman, a woman of principle, but the demands of nature are legitimate and powerful; they are in constant conflict with our reason and usually end up victorious. Let me finish. During my absence, even

when you are dutifully remembering me, you are still sure to feel the urge by which a woman attracts a man and is attracted by him. For a while I will be the object of your desire, but who knows what circumstances will conspire, what opportunities will present themselves so that another will reap in reality the fruit that imagination had destined for me. Please be patient for a while longer and hear me out.

' "Should the case arise – which you say is impossible and I do not wish to precipitate – that you can no longer do without the company of a man, no longer deny yourself the pleasures of love, then promise me that you will not choose one of the thoughtless boys to take my place. However charming they may look, they are even more dangerous to a woman's honour than to her virtue. Led more by vanity than by desire, they pay court to any and every woman, and nothing seems more natural to them than to sacrifice one woman for another. If you feel the inclination to look for a man as a friend, then look for one who deserves that name, one who is modest and discreet, one who increases the pleasures of love with the blessing of secrecy."

'At this his beautiful wife could no longer conceal her pain and the tears, which she had so far held back, flowed in torrents. "Whatever you may think of me," she cried after a passionate embrace, "nothing is further from my thoughts than the crime you seem to believe is inevitable. If ever I should even think such a thing, may the ground open and swallow me up, may I forfeit all hope of salvation, that promises us such a delightful continuation of our

existence. Put away your mistrust and leave me with the unalloyed hope of seeing you in my arms again soon."

'After he had done everything he could to calm his wife, he set sail the next morning and soon arrived safely in Alexandria. In the meantime his wife, secure in the possession of great wealth, lived at her pleasure, a life of ease but in seclusion, seeing no one apart from her parents and relatives. And while faithful servants carried on her husband's business affairs, she lived in a large house, and in its magnificent rooms her thoughts were daily with her husband.

'However secluded and quiet her life, the young men of the town were not idle. They took every opportunity to parade up and down outside her windows and tried to attract her attention in the evening with music and song. At first the fair recluse found these efforts irritating, a nuisance, but she soon became accustomed to them and on the long evenings enjoyed the serenades as a pleasant entertainment, without concerning herself with the performers. She often could not repress a sigh for her absent husband.

'Instead of her unknown admirers gradually tiring, as she had hoped they would, their efforts seemed to increase, promising to become a permanent institution. By now she could already distinguish the recurrent instruments and voices, the repeated melodies, and soon she could not resist the temptation to find out who her unknown serenaders were, especially the more persistent ones. Surely there was no harm in that, to pass the time?

'So she started looking out into the street through the blinds and curtains, watching the passers-by, taking especial note of the men who kept their eyes fixed on her windows longest. They were mostly handsome, well-dressed young men, whose manner, however, as well as their whole appearance betrayed as much empty-headedness as vanity. They seemed more interested in drawing attention to themselves by besieging the beautiful woman's house than in expressing their admiration for her.

' "Truly," the lady sometimes said jokingly to herself, "that was a clever idea my husband had. The condition under which he allowed me to choose a lover excludes all those who are paying me court and whom I might find attractive. He is well aware that modesty and discretion are characteristics of a calm maturity which our reason values, but which are not at all the kind of thing to stimulate our imagination or arouse our desire. Looking at those who are laying siege to the house with their attentions, I am sure they are not the type to inspire confidence, while those who do inspire confidence, I do not find in the least desirable."

'Safe in this belief, she gave herself up more and more to the pleasure of the music and the sight of the young men walking past the house and, without her realising, a restless desire slowly but surely grew in her breast; by the time it occurred to her to resist, it was too late. Solitude and idleness, the good, comfortable life with everything provided was just the element in which an unlawful desire was bound to emerge sooner than the poor dear girl imagined.

'Now, though with many a repressed sigh, she began to marvel at her husband's understanding of the world and of human nature, but above all of a woman's heart. "So what I disputed so vigorously was possible after all," she said to herself, "it *was* necessary for him to advise me to proceed wisely and with caution should the case arise. But what use are wisdom and caution when it just seems to be a matter of pitiless chance toying with a vague longing? How can I choose a man I don't know? And once I know him better, do I still have a choice?"

'With this and a hundred other thoughts the beautiful young woman only exacerbated her condition, which was bad enough as it was. In vain she sought distraction: every pleasant object aroused her emotions, and even in the depths of solitude her emotions sparked off pleasant images in her imagination.

'This was her condition when she heard from her relatives, among other items of news, about a young lawyer who had studied in Bologna and just returned to his home town. They could not praise him enough. He combined, they said, exceptional knowledge with skill and understanding such as are not usually found in a young man, and despite his very handsome appearance, he was extremely modest. As an attorney he had quickly won the trust of the townspeople and the respect of the judges. He went to the town hall every day where he carried out his duties.

'Hearing this description of such a perfect man, the beautiful young woman could not repress the desire to make his acquaintance, nor the silent wish that he might be the man to whom she could give her

heart, even under the conditions her husband had set. Naturally, then, her attention was aroused when she heard that he passed her house daily; how diligently did she observe the time at which they usually gathered in the town hall! It was not without emotion that she finally saw him walk past; and if she could not help but be attracted by his handsome figure and youth, his modesty, on the other hand, was to give her cause for concern.

'After observing him in secret for a few days, she could no longer resist the desire to attract his attention. She dressed carefully and went out onto the balcony. How her heart pounded when she saw him coming along the street! And how disconsolate, even ashamed, she was, when she saw him walk past as usual, with measured steps, wrapped in thought, eyes cast down, and continue on his graceful way without even noticing her.

'Several days running she tried in this way to get him to notice her, but in vain. He always walked past at the same pace, without raising his eyes or turning his head this way or that. But the more she looked at him, the more he seemed to be the one she needed so badly. Her feeling towards him became stronger every day until finally, since she did nothing to resist, it was quite overpowering. "Your noble, understanding husband," she said to herself, "foresaw the way you would feel during his absence, that you could not live without a friend to enjoy your favours. And now that his prophecy has been fulfilled and fortune has shown you a young man who suits you perfectly and suits the conditions your husband set, a

young man with whom you could enjoy the pleasures of love in impenetrable secrecy, must you languish and pine away? It would be foolish to miss the opportunity, foolish to resist overpowering love."

'With such arguments among many others she strengthened her resolve and it was only for a short while that she was pulled hither and thither by uncertainty. Finally – as so often happens, when a passion which we have resisted for a long time eventually carries us away and we look down with contempt on concern, fear, caution, modesty, situation and duties as petty obstructions – she came to an abrupt resolve and sent a young girl, who was a servant in the house, to the man she had fallen in love with in order to possess him whatever the cost.

'The girl hurried off and, finding him at table with a large number of friends, gave him the precise message her mistress had taught her. The young attorney was not surprised to receive this summons. As a youth he had known the merchant; he knew that he was at present abroad and, although he had only heard of his marriage at second hand, assumed that the wife, in the absence of her husband, probably needed his advice on some important legal matter. He therefore replied most courteously to the girl, assuring her that he would not fail to attend her mistress as soon as the meal was over. When she heard that she would soon see the man she loved, the beautiful woman's joy knew no bounds. She hurried away to put on her best clothes and quickly had the house and her rooms cleaned and tidied. Orange blossom and flowers were strewn around, the sofa covered

with costly rugs. Thus she kept herself occupied for
the brief time before he arrived, which she would
otherwise have found unbearably long.

'Imagine her emotion as she went to greet him, her
agitation as she bade him sit on a stool close beside
the divan, on which she sat down. In his presence, so
fervently desired, she was struck dumb; she had not
thought of what she was going to say. He, too, was
silent and sat beside her in a reserved posture.
Finally she plucked up her courage and said, not
without some trepidation and misgivings:

' "It is not long since you came back to your native
town, sir, but already you are recognised everywhere
as a talented and reliable man. I, too, am going to put
my trust in you in an important and unusual matter
which, when I think about it, is more a matter for my
father confessor than a legal adviser. I have been mar-
ried for a year to a worthy and wealthy man who, as
long as we were together, paid me every attention. I
would have no cause for complaint were it not that a
restless desire to travel and trade tore him from my
arms some time ago. As a fair man of great under-
standing he was well aware of the wrong he was doing
me by leaving me on my own. He realised that a
young wife could not be stowed away, like jewels or
pearls; he knew that she is more like a garden full of
lovely fruits, which will be lost to everyone, not just
to the owner, if he insists on locking the gate for a few
years. Thus before he left he had a very serious talk
with me, assuring me that I would find I could not
live without a friend, and not only did he give me
permission, he urged me, he as good as made me

promise to follow the inclination that would appear in my heart, freely and without hesitation."

She paused for a moment, but soon an encouraging look from the young man gave her the courage to continue her confession.

"There was one single condition my husband appended to his consent, which in all other respects was so very indulgent. He recommended extreme caution and specifically demanded that I should choose a sober, reliable, intelligent and discreet friend. Spare me the embarrassment of having to tell you the rest, sir, of having to admit how much I am taken with you, and deduce my hopes and desires from the way I have confided in you."

'After a short pause for reflection, this amiable young man said, "I am very grateful to you for the trust you have shown me, it is a great honour and pleases me immensely; my keenest desire is to convince you that the man you have turned to is not unworthy of it. Let me answer first of all as a lawyer. As such I confess that I admire your husband for seeing and feeling his offence so clearly; for, surely, a man who leaves a young wife behind in order to travel to distant countries is as guilty of dereliction of duty as a man who abandons any other item of property, thus clearly relinquishing all right to it. Just as any man has the right to take an item thus abandoned into his possession, I consider it even more natural and reasonable that a young woman in that situation need have no misgivings about transferring her affections to another man and taking a friend she finds pleasant and reliable.

' "And if, as here, we even have the case where the husband, aware of the wrong he is doing his abandoned wife, gives his express permission for that which he cannot forbid, then the case is beyond all doubt, especially since no wrong can be done to a man who has declared himself willing to accept it.

' "And if now you should choose me to serve you," the young man went on with a quite different expression and in impassioned tones, "then you would bring me such bliss as I have never known before. Be assured," he exclaimed, kissing her hand, "that you could have found no more devoted, tender, faithful and discreet servant."

'You can imagine how relieved the beautiful woman was at this declaration. She no longer hesitated to express her tender feelings openly; she squeezed his hands, pressed up against him and laid her head on his shoulder. They had not been in that position for long when he gently moved away from her and started to speak, not without a note of sadness in his voice: "Can any man ever have been in a stranger situation? I am compelled to restrain myself and keep away from you at the very moment when I should be abandoning myself to the sweetest emotions. At present there is something that prevents me from tasting the joys that await me in your arms. Oh, I hope the delay will not deprive me of my fondest hopes!"

'Anxiously, the fair lady asked what the reason for this strange declaration was.

' "Just as I was completing my studies in Bologna," he said, "and was working as hard as I could

to prepare myself for my future career, I contracted a serious illness which, though not life threatening, did threaten to damage my physical and mental health permanently. In my distress, and in great pain, I made a vow to the Madonna that if, with her aid, I should recover, I would fast rigorously for a whole year and refrain from all pleasure of whatever kind. I have kept this vow strictly for ten months now and the time has not hung heavy on me; considering the great blessing I received, I did not find it difficult to abstain from some of the good things I was used to. But now the two months that remain have come to seem an eternity, since I must wait until they have passed before I can taste a joy beyond belief. Bear the delay with patience and do not withdraw the favour you have so willingly destined for me."

'The fair lady was not particularly happy with this explanation, but her mood improved when her friend, after some reflection, went on, "There is a means by which I could be released earlier from my vow, but I hardly dare suggest it to you. If I could find someone who would agree to keep the vow as strictly and faithfully as I have and who would take over half the remaining time, then I would be free all the more quickly and nothing would stand in the way of our wishes. Would you be willing, my dear friend, to clear away part of the obstacle so that we can consummate our joy all the sooner? It is only to a person who is completely reliable that I can transfer part of my vow. It is very strict: I am only allowed bread and water twice a day, at night only a few hours sleep on a hard mattress, and despite my many

duties I must say a large number of prayers. If, as happened today, I cannot avoid attending a banquet, I am not allowed to suspend my vow; on the contrary, I must resist the temptation of all the delicacies borne past me. If you can undertake to follow all these rules for a whole month, then your pleasure in having a friend will be all the greater in that you will have acquired him, so to speak, by means of such a laudable task."

'The lady was not happy to hear of the obstacles in the way of her desire. However, seeing the young man in person had so increased her love for him that no trial seemed too hard if it would secure her something she valued so highly. So she said to him, in the most obliging tones, "My dearest friend, the miracle by which you recovered your health means so much to me that I see it as my duty, my joyful duty, to share in the vow you are bound to fulfil. I am delighted to be able to give you such a clear proof of my affection. I will stick precisely to your directions and nothing will divert me from that path until you release me from the obligation."

'After the young man had been through the precise conditions under which she could take over half of what remained of his vow, he left, assuring her he would soon return to see if she had managed to persevere in her resolve. So she had to let him go, without a handshake, without a kiss, and with a look that meant almost nothing. Fortunately this strange project kept her busy, as there were a number of things to do to change her way of life so completely. First of all the beautiful blossoms and flowers that she had

had scattered to welcome him were swept up; then the well-upholstered divan was replaced with a hard mattress on which she lay down to sleep, still hungry for the first time in her life after a supper of bread and water. The next day she was busy cutting out and sewing shirts, having promised to make a certain number for a hospice for the poor and sick. During this new and irksome task she kept her imagination occupied with pictures of her sweet friend and the hope of future delights, and as she indulged in these fantasies her meagre fare seemed to act as a tonic for her heart.

'A week passed in this way. By the end of it the roses in her cheeks had started to fade a little, clothes that used to fit were too big for her and she, usually so quick and lively, was weak and lethargic, but a further visit from her friend gave her new strength and life. He exhorted her to persevere in her resolve, encouraged her with his own example and allowed her a distant glimpse of future unalloyed pleasure.

'The works of charity continued and the strict diet was not relaxed. But – unfortunately! – she could not have been more exhausted had she suffered a serious illness. Her friend, who came to see her again at the end of the week, gave her most sympathetic looks and spurred her on with the thought that half of her trial was already over.

'Now the unaccustomed fasting, praying and sewing was becoming more tedious with every day that passed and the excessive abstinence seemed to be completely undermining the health of a body accustomed to rest and ample food. It came to the

point where she could no longer keep on her feet and, despite the warm weather, had to wrap herself up two or three times over in order to maintain what little body heat remained. She was no longer even capable of staying up and was eventually forced to take to her bed.

'Imagine the reflections she made on her condition, how often the strange sequence of events went through her mind and how distressing she found it when ten days passed without a visit from the friend for whose sake she had undertaken these great privations. However, these dark hours saw the beginnings of her complete recovery, indeed, they were decisive for it. When, soon afterwards, her friend appeared and sat by her bedside on the very same stool on which he had heard her initial declaration, urging her in friendly, almost tender tones to remain steadfast during the short time that was left, she interrupted him with a smile and said, "No more encouragement is necessary, my worthy friend, I will persist in my vow for these few more days with patience and in the conviction that you laid it on me for my own good. At the moment I am too weak to express all the gratitude I feel. You have preserved me for myself, you have given me back to myself and I acknowledge that from now on I owe my whole existence to you.

' "Truly, my husband was understanding and shrewd. He was fair-minded enough not to condemn a woman for a desire that might arise in her bosom through his own fault; he was even generous enough to let the demands of nature take precedence over his rights. But you, sir, are a man of reason and a

good man. You have made me aware that there is something else within us apart from desire, something that can balance it out; also that we are capable of forgoing any accustomed pleasure and putting aside even our most passionate desires. You have brought me to this way of thinking by a mistaken belief and hope; but neither of them are necessary any more once we have come to know the good and powerful self that dwells within us, calm and quiet, constantly giving us gentle reminders of its presence until it can take control. Farewell. You have in me a friend who will be delighted to see you in future. Influence your fellow citizens as you have me; do not only untangle the confusions that can easily arise over property, show them, by gentle guidance and by example, that everyone has the seed of virtue concealed within them. Your reward will be universal respect and you will deserve the title *Father of the Fatherland* more than the foremost statesman or the greatest hero." '

'Your attorney deserves our praise,' said the Baroness. 'He is elegant, rational, entertaining and instructive, just the way anyone should be who is trying to prevent us from going astray or to bring us back onto the straight and narrow. Your story is more worthy of the title of a moral tale than many others. Give us more of that kind and our little circle will certainly be delighted.'

Priest: 'If that story has your approbation, then I am content, but if you desire more moral tales I am sorry to have to say that it is the one and only one of that type.'

Luise: 'It doesn't say much for your collection if you only have a single example of the best kind.'

Priest: 'You misunderstand me. It is not the sole moral tale I can tell, but all of them are so similar that one seems to be telling the same one over and over again.'

Luise: 'You should give up these paradoxes, they only confuse the discussion. Please explain yourself more clearly.'

Priest: 'Willingly. The only stories that deserve the title "moral" are those which show us that people have within them the strength to act against their own desire out of the conviction that there is something better. That is what this story teaches us and no moral tale can teach us anything else.'

Luise: 'So in order to act morally, I must act against my own desire?'

Priest: 'Yes.'

Luise: 'Even when my desire is good?'

Priest: 'No desire is good in itself, but only insofar as it produces a good effect.'

Luise: 'What if I should desire to do works of charity?'

Priest: 'Then one should ban oneself from doing charitable works the moment one sees that they are ruining one's own household.'

Luise: 'And what if one should have an irresistible urge to show one's gratitude?'

Priest: 'Human nature is such that gratitude can never become an irresistible urge. But even if it were to do so, a person who preferred to appear ungrateful, rather than do something reprehensible out of

love of his benefactor, would be worthy of our admiration.'

Luise: 'So there could be countless moral tales after all?'

Priest: 'In that sense, yes. But none of them would say anything other than what my story of the attorney said, so that one could call it the sole moral tale as far as the theme is concerned; you are right, of course, to point out that the material can vary widely.'

Luise: 'If you had expressed yourself more precisely we wouldn't have had an argument.'

Priest: 'Nor a discussion. Misunderstandings and confusion make the world go round and keep conversation going too.'

Luise: 'I still cannot entirely agree with you. If a brave man were to put his own life at risk to save another, would that not be a moral act?'

Priest: 'Not in my use of the word. If, however, a timorous man overcame his fear to do that, then that would be a moral act.'

Baroness: 'I would prefer it, my friend, if you would put off your discussion with Luise about the theory to another occasion and give us a few more examples. It is true that we rejoice when we observe someone with a natural disposition towards goodness, but nothing in the world can compare with desire guided by reason and conscience. If you have another story of that kind, then we would like to hear it. I am very fond of parallel stories: one points to the other and explains its meaning better than any number of dry words.'

Priest: 'I do have a few more I can tell that are relevant here, since I have paid special attention to these qualities of the human mind.'

Luise: 'There is just one thing I would like to ask. I cannot deny that I do not like stories which insist on carrying our imagination off to foreign countries. Must everything take place in Italy and Sicily, in the East? Are Naples, Palermo and Smyrna the only places where interesting things happen? I don't mind fairy tales being set in Samarkand or Hormuz in order to stir our imagination, but if you want to educate our minds and hearts then give us ones set in our own country, give us family portraits so that we will recognise ourselves all the more easily and, if we see ourselves in them, we will be all the more deeply moved.'

Priest: 'In that too your will shall be done. But there is a problem with family portraits. They all look so much alike and we have seen almost all possible relationships in them worked out in our theatres. However, I will take the risk and tell you a story. You will know something similar already and it can only be new and interesting through a precise description of what is going on within the characters.

'In families one can often observe that children have inherited features – both mental and physical – sometimes from their father, sometimes from their mother. And thus it occasionally happens that a child combines the characteristics of both parents in a special and remarkable way.

'A young man, whom I will call Ferdinand, was a

93

striking example of this. His external appearance recalled both parents, and their temperaments could also be clearly distinguished in his. He had his father's easygoing and cheerful disposition, as well as his urge to enjoy the moment, and, in certain circumstances, a rather intense way of only taking himself into consideration. From his mother, on the other hand, he appeared to have inherited the ability to reflect on things calmly, a sense of right and justice, and the strength to sacrifice himself for others. From all this one can easily see that those who had to deal with him were often forced, when trying to account for his actions, to take refuge in the hypothesis that the young man must have had a dual nature.

'I will pass over all kinds of episodes that occurred in his youth and recount just one, which throws light on his whole character and brought about a decisive turning point in his life.

'From earliest childhood he had enjoyed a lavish style of life. His parents were well-off and lived and brought up their children as befits such people. And if his father spent more than he should drinking with friends, at the gaming tables or on elegant clothes, his mother, as a thrifty housekeeper, was able to limit their everyday expenses so that there was a balance overall and never any shortages. The father enjoyed good fortune as a merchant; many of his bold ventures succeeded and, since he was very sociable, his business affairs profited from his many connections and a not infrequent helping hand.

'Children naturally strive to develop and generally choose as their model the one in the family who

seems to live life to the fullest, with the greatest enjoyment. They take a father who enjoys life as their guiding light, and since they come to this view fairly early on, their wishes and desires mostly grow out of all proportion to the resources of their families. They soon find themselves held back on all sides, especially as every new generation makes different and earlier demands, while the parents are usually only willing to allow their children the things they enjoyed in earlier times, when everyone was happy with more moderate and simpler lives.

'Ferdinand grew up with the irritating feeling that he often lacked things he saw his friends had. He did not want to be second to anyone in clothing, in a certain liberality of lifestyle and behaviour. He wanted to be like his father, whose example he had daily before him and who played a double role as a model: in the first place as a father, towards whom a son is usually favourably disposed, and then because the boy could see that, living the way he did, the man led a life of enjoyment and pleasure, at the same time being respected and loved by everyone. This led, as you can well imagine, to frequent arguments with his mother, since Ferdinand refused to wear his father's cast-off clothes, wanting to be in the latest fashion himself. Thus he grew up, and his demands grew with him so that eventually, when he was eighteen, he felt there was a great discrepancy between what he was and what he wanted to be.

'So far he had not made any debts, his mother having instilled a great horror of them in him. She had endeavoured to keep him happy and several

times had done her utmost to fulfil his wishes or help him out when he was short of money. Now however, when, as a young man, he was even more concerned with outward appearance, he had fallen in love with a very beautiful girl who was involved with the fashionable set, and he wanted not just to be equal to others, but to cut a figure and stand out from them. Unfortunately, at this very point his mother had less to spare from her housekeeping than ever before, so that instead of satisfying his demands, as she usually did, she began to appeal to his common sense, his better nature, his love for her; she succeeded in convincing, but not in changing him, so that he was truly desperate.

'He could not change his way of life without losing everything which was as dear to him as life itself. It was what he had been growing towards from earliest childhood, so that he was inextricably interwoven with everything around him; he could not break a single thread of his connections, parties, walks or excursions without, in so doing, offending an old school-friend, a playmate, a new acquaintance that did him honour or, what was worst of all, his beloved.

'What his affection meant to him can easily be seen when you realise that it aroused not only his sensuality but also his mind, his vanity and his liveliest hopes. One of the most beautiful, pleasant and richest girls of the town preferred him, at least for the present, to his many rivals. She allowed him to make a show of his attentions, and they seemed to be equally proud of the chains they had attached to each other. Now he saw it was his duty to follow her

everywhere, to spend time and money in her service and show her in every way how highly he valued her affection and how he could not live without her.

'His association with this girl and his desire to impress her involved Ferdinand in greater expenditure than would have been normal under other circumstances. Her absent parents had left her in the care of a very eccentric aunt and it took all kinds of artful ruses and bizarre stratagems to get Ottilie out into the society of which she was such an adornment. Ferdinand exhausted himself thinking up devices to allow her to join in the amusements she enjoyed so much and which she did so much to enhance for all around her.

'To be reminded, just at that point, by the mother whom he loved and respected, of other, quite different obligations, to find no help from that quarter, to have a keen abhorrence of debts which, anyway, would not have solved his difficulty for long, and at the same time to be seen as wealthy and open-handed, whilst daily aware of his urgent need of money, was surely one of the most tormenting situations imaginable for a young man at the mercy of his passions.

'Certain ideas, which had formerly been mere passing fancies, now took a stronger hold on him, certain thoughts, which so far had only troubled him for brief moments, now preyed on his mind, and certain feelings of resentment became more lasting and bitter. Whereas previously he had regarded his father as a model, he now envied him as his rival. He possessed everything the son wished for; everything which

caused the latter concern was easy for the former.
And it was not a matter of necessities, but of things
either of them could have done without. The result
was that the son began to think his father ought to
do without things now and then, in order to allow
him to have what he lacked. His father, on the other
hand, was of a quite different opinion. He was one of
those people who deny themselves little and therefore
get into a situation where they deny much to those
who are dependent on them. He had made his son a
specific allowance and insisted that he account for it,
indeed, he demanded regular accounts.

'Nothing sharpens a person's eye as much as being
restricted. That is why women are so much shrewder
than men; and there is no one on whom subordinates
keep a closer watch than a superior who gives orders
without leading by example. Thus the son kept a
sharp eye on all his father's actions, especially those
concerned with spending money. He pricked up his
ears when he heard that his father had lost or won at
the gaming table; he was more severe in his judgment
of him when he heard that he had treated himself to
something expensive.

' "Is it not strange," he said to himself, "that par-
ents can indulge in all kinds of pleasure, spending the
fortune that chance has given them in any way they
think fit, while denying their children the pleasures
they are entitled to at the very time when, being
young, they can enjoy them best? By what right do
they do it? And how did they come by that right?
Should chance decide everything? Can we talk of a
right when it is the result of chance? I would be

much better off if Grandfather were still alive; he treated his grandchildren the same as his children, he would not have let me go without the bare necessities. Is necessities not the correct word for the things we need in the circumstances in which we have been born and brought up? Grandfather would not have let me go without, no more than he would have tolerated father's spendthrift ways. Had he lived longer, he would have clearly seen that his grandson has a right to his pleasures too; perhaps he would have made his will in such as way as to allow me to enjoy my happiness sooner. I have even heard that Grandfather died suddenly, just as he was about to make his will. Perhaps, then, it is purely chance that has deprived me of an earlier share in a fortune which I might lose for good if my father continues to behave in this fashion."

'It was with sophistries such as this about possession and right, about whether one needed to observe a law or arrangement in which one had had no say, about how far it was permissible quietly to ignore civil law, that he often passed those morose hours when, for want of ready cash, he had had to refuse an invitation to some excursion or other pleasant social occasion. He had already sold small items of value that he possessed and his usual pocket money was simply not sufficient.

'He became withdrawn, and one can say that at such moments he did not respect his mother, who could not help him, and hated his father, who, in his opinion, was everywhere in his way.

'It was at this time that he made a discovery which

only served to increase his resentment. He noticed that his father was not only profligate with his money, he was not very good at keeping an account of it, for he would often take money out of his desk in a hurry, without noting it down. Sometimes he would start counting and calculating later on and get annoyed that his sums did not agree with the money in his desk. The son noticed this repeatedly and he was all the more irritated by it when he saw his father helping himself to money by the handful at a time when he himself was decidedly short of cash.

'In this mood, a strange chance provided him with a tempting opportunity to do something which until then had just been a vague, indecisive urge.

'His father gave him the task of looking through a box full of old letters and putting them in order. One Sunday, when he was alone in the house, he was carrying the letters through the room where the desk was in which his father kept his cash. The box with the letters was heavy; he had not picked it up in the right way and wanted to put it down for a moment or, rather, simply rest it on something. Unable to hold it any longer, he crashed into the edge of the desk and the lid flew open. He saw all the rolls of money, on which until now he had just cast the occasional sidelong glance, lying there before him and, without thinking, without considering what he was doing, he took one roll from the side where his father kept the money for his incidental expenses. He closed the lid of the desk and tried knocking it from the side again. Every time the lid flew open; it was as good as having the key to the desk.

'Now he flung himself into every pleasure which so far he had had to do without. He was even more attentive to his fair lady; there was a more passionate intensity about everything he did; his lively, charming disposition had been transformed into a vehement, almost wild temperament which, while it suited him quite well, was not particularly agreeable to others.

'What a spark is to a loaded rifle, the opportunity is to an urge, and every urge that we satisfy against our conscience forces us into an excess of physical exertion. We are back acting like savages and it is difficult to stop the effort it costs us from becoming evident on the outside.

'The more his inner feeling told him he was wrong, the more he piled up specious arguments; the more constrained he felt on the one side, the freer and bolder he appeared in his actions.

'At that time all sorts of expensive trinkets had become fashionable. Ottilie loved to adorn herself and Ferdinand looked for a way to give her such trinkets without her knowing whom they came from. It was made to look as if an old uncle was the donor and it gave Ferdinand double pleasure to hear his beloved Ottilie express, in almost the same breath, her happiness at the gifts and her suspicion of her uncle.

'In order to give himself and her this pleasure, he had to open his father's desk several more times, but that caused him little concern, since at various times his father had put in and taken out money without noting it down.

101

'Not long after that Ottilie was due to leave to stay with her parents for several months. The young pair were extremely sorrowful at the prospect of parting and one circumstance made the separation even more significant. By chance Ottilie learnt that the presents were from Ferdinand. She demanded to know the truth, and when he confessed, she seemed very annoyed. She insisted he take them back. It was a suggestion that cut him to the quick and he told her he could not, would not live without her, asked her to stay true to him and begged her not to refuse him once he was provided for and had his own establishment. She loved him, she was deeply moved and accepted his proposal; and in that happy moment they sealed their promise with the most fervent embraces and a thousand heartfelt kisses.

'After she left, Ferdinand felt very much alone. The social gatherings where he used to see her no longer attracted him now that she was absent from them. It was only out of habit that he went to see friends and visited places of amusement, and it was only with reluctance that he helped himself to his father's cash a few more times to meet expenses for things he did not really want. He was often alone and his good side seemed to be gaining the upper hand. He was amazed, now he had the chance to think things over calmly, at the calculating way he had used the false logic of his sophistries about legality and possession, about the right to other people's property, and all the other abstractions, to gloss over an action that was simply wrong. He gradually came to see that it was only people who acted in good faith

who were estimable, that a good person had to live in a way that put all the laws to shame, while another would try to circumvent them or use them to his advantage.

'In the meantime, before these good and true thoughts had become quite clear and led him to take decisive steps, he had succumbed to the temptation to dip his hand into the forbidden supply a few more times in cases of urgent need. Not once, however, did he do so without reluctance, as if he were being dragged there by an evil spirit.

'Finally, however, he plucked up his courage and resolved first and foremost to make his depredations impossible by warning his father about the state of the lock. He went about it in a clever way. When his father was present, he carried the box of letters, now put in order, across the room and, with deliberate clumsiness, let the box knock against the desk. Imagine his father's surprise when he saw the lid shoot open. They both inspected the lock and found that with age the catches had become worn and the hinges loose. It was repaired immediately and it was a long time since Ferdinand had felt so happy as now that he knew the money was safely locked away.

'But he was not content with that. He immediately determined that he would get together the sum he had stolen from his father – he knew how much it was – and find some way or other of letting him have it back. He began to live as sparingly as possible and to save as much as possible out of his pocket money. Of course, what he could put aside from that was very little compared with the amount he had

previously squandered. But in a way the sum seemed large to him because it was a start towards redressing the wrong he had done. And it is true that there is a huge difference between the last thaler one borrows and the first one pays back.

'He had not been following this noble path for long when his father decided to send him away on business. He was to familiarise himself with a factory that was a long way away. The intention was to set up an office in a region where basic living expenses and labour were cheap, and instal a partner there, in order to exploit the advantages their rivals currently enjoyed and, by investment and credit, expand the factory. Ferdinand was to investigate the matter on the spot and send back a detailed report. His father had assigned him a sum for expenses, stipulating he keep within it; it was more than sufficient and Ferdinand had no complaints.

'On his journey Ferdinand continued to live in a very economical manner, calculating everything twice over, and he found that he could save a third of his allowance, if he kept to his thrifty ways. He hoped to find the opportunity to get the rest he needed to pay off his debt and he was granted it. Opportunity is an even-handed goddess who favours both good and evil.

'In the area he was to visit he found that things were far more favourable than they had thought. Everyone was still following the easy-going, old-fashioned ways and doing everything manually. They had no knowledge of new developments, or at least had not used them. They invested moderate

sums and were happy with a moderate profit, and
Ferdinand soon realised that with a certain amount
of capital, with advances, by buying the raw
materials in bulk and bringing in machines with the
help of competent overseers they could set up a
large-scale operation on a sound footing.

'He felt very uplifted at the idea of being actively
involved in all this. The magnificent countryside,
where, in his mind's eye, he constantly saw his
beloved Ottilie, gave rise to the wish that his father
would set him up there, would entrust him with the
new enterprise, thus unexpectedly making ample
provision for him.

'He paid all the more attention to everything,
because he already saw it as his. It was the first time
he had had the opportunity to employ his know-
ledge, his mental powers, his judgment. The region as
well as the things in it aroused his intense interest,
they were balm to heal his wounded heart. He still
found it painful to think back to his home where, in a
kind of madness, he had committed an act which
now seemed a most heinous crime to him.

'He was accompanied everywhere by an associate
of his firm, a capable man but with poor health, who
had first put forward the notion of such an enterprise
in his letters. He told Ferdinand his ideas and was
delighted when the young man accepted, indeed
anticipated them. This man lived very simply, partly
out of preference, partly for the sake of his health.
He had no children; a niece looked after him. He had
made her his heir and hoped she would find an hon-
est, energetic husband who would bring the capital

and vigour needed to carry through the scheme,
which he could visualise but which the state of his
health and fortune made it impossible for him to
realise.

'Hardly had he seen Ferdinand than he felt he was
his man, and his hopes grew as he observed the
young man's keen interest in the enterprise and the
area. He hinted at his thoughts to his niece and she
seemed to have no objection. She was a young girl,
well-formed and healthy, of an excellent disposition
in every respect. Looking after her uncle's household
kept her nimble and active, looking after his health
gentle and obliging. She was everything one could
hope for in a wife.

'Ferdinand, with eyes for the lovely Ottilie's love
alone, hardly noticed the country girl, at most wish-
ing that when Ottilie was settled there as his wife
he would be able to provide a housekeeper like that
for her. He responded to her friendly and obliging
manner in a very free-and-easy way; he got to know
her better and came to hold her in high regard,
soon showing her greater respect; she and her uncle
interpreted his behaviour according to their wishes.

'By now Ferdinand had had a close look at every-
thing and learnt what he needed to know. With the
help of the girl's uncle he had drawn up a plan and,
in his usual carefree manner, had not concealed from
him that he counted on carrying out the plan him-
self. At the same time he had paid the niece many
compliments and said how lucky the household
would be that had such a conscientious housewife
in charge of it. As a result she and her uncle were

convinced he had serious intentions and therefore did everything they could to oblige him.

'In the course of his investigations Ferdinand had been pleased to discover that not only did this place offer much for the future, but that there was a profitable transaction he could enter into right away which would allow him to return the stolen money to his father and free him once and for all from that oppressive burden. He disclosed his intended venture to his friend, who was extremely pleased at it and gave him all the assistance he could. Indeed, he wanted to acquire everything for his young friend on credit, which, however, the latter did not accept; instead he made an immediate part-payment from what he had saved out of his travel expenses, promising to pay off the rest within an agreed period.

'His delight as he had his goods packed and loaded knew no bounds; his sense of satisfaction as he set off on his journey home can be well imagined. The sweetest feeling a person can have is when, though their own efforts, they have risen above a serious error, a crime even, and freed themselves from it. A good person, who makes his way along the straight and narrow without noticeable deviations, is like a calm, worthy citizen, whereas the other is a hero, a conqueror, who deserves our admiration and praise. This seems to be the sense of the paradoxical verse from the Bible according to which there is more joy in heaven over one sinner that repents than over ninety-nine just persons.

'Unfortunately for Ferdinand, all his good resolutions, his reform, his repayment of the money could

not save him from the consequences of his actions which were awaiting him on his return to disrupt his newly won calm. During his absence a storm had been brewing which was to break the moment he entered his father's house.

'As far as his personal finances were concerned, Ferdinand's father, as we know, was not the most orderly person; his business accounts, on the other hand, were kept in perfect order by a very capable and precise partner. He had not noticed the money his son had stolen except that, as chance would have it, there was among it a packet of coins which were unusual in that region and which he had won from a visitor to the area at the gaming table. He did notice that they were missing and that made him think. What he then found even more disturbing was that he could not find several rolls, each containing a hundred gold ducats, which he had lent out to someone a while ago, but which he was certain he had received back. He knew that previously the desk could be opened by knocking it and came to the conclusion that he had been robbed, which made him exceedingly angry. His suspicious mind looked here, there and everywhere. He told his wife what had happened, issuing the most dreadful threats and curses: he was going to turn the house upside down, have all the servants, maids and children questioned, no one was free from suspicion. The sensible woman did her best to calm her husband down, pointing out the embarrassment and discredit this could bring on him and his firm if it should become known, adding that no one would genuinely feel for them in their plight, only

humiliate them with expressions of sympathy; that neither he nor she would be spared and might even be the subject of more grotesque suggestions if nothing came of it; that it might be possible to find the culprit and recover the money without plunging him into misfortune for the rest of his life. Having made these and other points she managed to persuade him to calm down and pursue his investigations in secret.

'And the discovery was not far off. Ottilie's aunt had been told of the young pair's promise to each other and she knew of the presents her niece had accepted. She was unhappy about the whole affair, Ottilie's absence being the only reason she had not said anything. A lawful relationship with Ferdinand she saw as advantageous, but she shuddered at the idea of an illicit affair. When she heard, therefore, that the young man was due back soon, and expected her niece's return any day, she made haste to tell his parents what had happened and hear their opinion, to ask whether provision would soon be made for Ferdinand and whether they would agree to a marriage with her niece.

'His mother was no little surprised, when she heard of the situation, and horrified when she was told of the presents Ferdinand had given Ottilie. She concealed her amazement, however, and asked the aunt to give her a little time until she found an opportunity to discuss the matter with her husband, at the same time assuring her she thought Ottilie was a good match and that it was not impossible a suitable situation might be found for her son in the near future.

'Once Ottilie's aunt had left, Ferdinand's mother did not think it advisable to tell her husband what had been revealed to her. All she wanted to do was to clear up the unfortunate mystery as to whether Ferdinand, as she feared, had bought the presents with the stolen money. She hurried to see the merchant who sold most of that kind of jewellery and haggled for some similar pieces, saying finally he shouldn't try to overcharge her since her son, who had ordered a set like that, had got them more cheaply. The merchant assured her that was not the case and gave the exact prices, adding that they had to be increased by the commission for converting the currency Ferdinand had paid with in part. To her dismay, the currency he mentioned was the kind that had disappeared from her husband's desk.

'To keep up the pretence, she took a note of the last prices she had been given, then left with a very heavy heart. That Ferdinand had erred was all too plain to see and, as was her nature, she feared the worst kind of deed and the most terrible consequences. She was sensible enough to conceal her discovery from her husband and awaited her son's return, torn between fear and longing. She wanted to find out the truth and feared she would hear the worst.

'Finally he came back, in a very cheerful mood. He could expect praise for the business he had carried out, and at the same time the goods he brought concealed the repayment with which he intended to free himself from his secret crime.

'His father received his report well, but not as

enthusiastically as he had hoped. He was distracted by the business with the money, which had put him in an ill-humour, all the more so because at that moment he had several considerable bills to pay. Ferdinand found his father's mood depressing, even more the presence of the walls, the furniture, the desk, which had been witnesses to his crime. All his joy was gone, his hopes and expectations; he felt he was a mean person, even a bad one.

'He was about to look for a way to sell his goods, which were due to arrive soon, without arousing attention, hoping the activity would draw him out of his wretched mood, when his mother took him to one side and reproached him, lovingly but earnestly, for the theft, leaving him no way of denying it. Ferdinand was moved to tears. He threw himself at her feet, confessed and begged her forgiveness, assuring her that it was only his love for Ottilie that had led him astray and that there had been no other fault than that. He then told her how he had come to feel remorse for his action, how he had deliberately shown his father that the desk could be opened and how he was now in a position to pay the money back with the savings he had made on his journey and the proceeds of a successful business venture.

'His mother refused to be won round with that, insisting he tell her what he had done with such large sums of money, for the presents only accounted for a small part. To his horror, she showed him a calculation of what was missing from his father's desk. He swore by all that was dear to him that he had not touched the gold and claimed he had not even taken

111

all the silver. At this his mother grew extremely angry. She accused him of trying to fob off his mother, who loved him dearly, with denials, lies and fairy tales, adding that a man who could steal silver was well capable of stealing gold. He probably had accomplices among his good-for-nothing friends, she went on, he had probably financed his business venture with the stolen money and he certainly would not have mentioned it at all had chance not brought his misdeed to light. She threatened to expose him to his father's anger, to the full rigour of the law, to cut him off without a penny; but nothing hurt him more than when she let slip that an engagement to Ottilie had been recently discussed. She herself was sad at heart when she left him, and he was in a sorry state. His misdeed had been discovered, and he was even suspected of having committed a worse crime. How could he convince his parents that he had not touched the gold? Given his father's violent temper, a public scene was to be feared. He saw himself becoming the very opposite to what he might have been. The prospect of a life of fruitful activity, of marriage to Ottilie, had vanished. He saw himself cast out, a fugitive in foreign lands exposed to all kinds of hardship.

'But even all this, his confused imaginings, his hurt pride, his disappointed love, was not what caused him the greatest pain. What cut him to the quick was the fact that his honest intention, his manly resolve, the plan he had put into action to make good the wrong he had done, should have been completely misconstrued, denied, taken for its very

opposite. While the former plunged him into dark despair, in that he was forced to confess that he deserved his fate, the latter touched him to the very core as he learnt the bitter truth that the best of intentions can be ruined by an evil deed. Being turned in on himself like this and realising that his noblest efforts were to be in vain brought him to the point when he no longer wished to live.

'In these moments his soul cried out for succour from on high. He fell to his knees by his chair, wetting it with his tears, and demanded help from the Divine Being. What he prayed for was worthy of being granted: a man, he said, who can rise above his own vice, deserves direct help; a man who does everything within his power has a claim, when that is not sufficient, on the support of the Heavenly Father.

'He persisted for a while in that conviction, in that urgent plea, and scarcely noticed when the door opened and someone came in. It was his mother who, coming up to him with a smile on her face, saw his distress and spoke comfortingly to him. "How happy I am," she said, "that at least I know you are not a liar and can take your remorse as genuine. The gold has been found. Your father, when his friend returned it to him, gave it to the cashier to look after, but forgot that because of all the things he had to occupy him. The silver tallies pretty well with your account, the total sum is now much less. I could not conceal my heartfelt joy, and promised your father I would replace the missing sum if he would promise to calm down and ask no more about the matter."

'Ferdinand's misery was immediately transformed

113

into joy. He set about selling his goods as quickly as possible and was soon able to give his mother the money. He even replaced the amount he had not taken, knowing full well that it was simply through his father's slipshod manner with his expenses that it had gone missing. He was happy and cheerful, though the whole incident had had a serious effect on him. He had convinced himself that people have the strength to desire good and to act on it. He also believed that in acting in that way, a person could attract the attention of the Divine Being and could count on His direct intervention, as had been his own recent experience. Joyfully he now revealed to his father his plan to settle in the region he had visited, detailing the whole extent and value of the enterprise he hoped to establish. His father was not averse to the idea, and his mother secretly told her husband of Ferdinand's relationship with Ottilie. He liked the idea of such a brilliant match for his son and was much attracted by the prospect of being able to set him up at no great expense. –

'I like this story,' Luise said when the priest had finished, 'and although it is taken from ordinary life, it doesn't strike me as everyday. When we look at ourselves and observe others, we find that we are seldom induced to forgo this or that desire of our own free will; usually it is external circumstances that compel us.'

'I wish,' said Karl, 'that it was never necessary to forgo something; I wish we were never made aware of things we are not going to be able to enjoy. Unfortunately, in our situation everything is packed

so close together, every space is planted out, all the trees are heavy with fruit and we just have to walk underneath them, content with the shade and forgoing enjoyment of the delicious fruits.'

'Let us hear the rest of your story,' Luise said to the priest.

Priest: 'It is already finished.'

Luise: 'We have heard the development, true, but now we would like to hear the dénouement.'

Priest: 'You have made a genuine distinction there, and since you are interested in the fate of my friend, I will tell you briefly how he fared.

'Freed from the oppressive burden of such an ugly misdeed, and not without a certain feeling of self-satisfaction, he now gave thought to his future and longed for Ottilie's return so that he could declare himself and make good his word. She arrived, accompanied by her parents. He hurried to see her and found her more beautiful, more radiant than ever. Impatiently he waited for the moment when he could speak with her alone and acquaint her with his prospects. The moment came and with a lover's joy and tenderness he told her of his hopes, how his future was close to being settled and how much he wanted to share it with her. Imagine his amazement, indeed his consternation, at her light-hearted, one could almost say mocking response. She made some not particularly subtle jokes about the rural retreat he had chosen, about the figure they would cut as a shepherd and shepherdess fleeing to the shelter of their thatched cottage, and other similar remarks.

'Angry and dismayed, he withdrew into himself; her behaviour had grieved him sorely and for a moment he grew cold. She had treated him unfairly, and now he noticed faults in her which until then he had not seen. Also it did not take a very sharp eye to see that a so-called cousin, who had come with them, had captured her attention and a large part of her affections.

'Despite the unbearable pain he felt, Ferdinand soon pulled himself together; he had made one effort of will and succeeded, and it seemed possible to do so again. He saw Ottilie frequently and he brought himself to the point where he was able to observe her. He was friendly, even tender in his manner towards her, and she equally towards him, but her charms had lost their power and he soon came to feel that with her very little came from the heart. On the contrary, she could be tender or cold, charming or aloof, pleasant or moody, just as she wished. Gradually the feelings that bound him to her loosened and he decided to cut the last ties.

'This operation proved more painful than he had imagined. One day he found her alone and plucked up the courage to remind her of the word she had given and recall the moment when the two of them, filled with the most tender emotion, had made an agreement regarding their future lives. She was friendly, indeed, one might almost say tender. He softened and wished everything were different from the way he had imagined it was. But he pulled himself together and, calmly and lovingly, told her all about the business he was going to set up. She

seemed pleased, her only regret apparently being that it would postpone their union even longer. She gave him to understand that she had not the least desire to leave the city and indicated her hope that a few years' work in that distant region might put him in a position to cut a grand figure among his present fellow citizens. She made it perfectly clear that she expected him in future to outdo his father and be more eminent and more worthy in everything.

'Ferdinand was only too well aware that a union with her would not bring him happiness, and yet it was difficult to renounce all those charms. Perhaps he might have still been undecided when he left her, had not the cousin turned up and showed excessive familiarity in his manner towards Ottilie. Once home, Ferdinand wrote her a letter, in which he once more assured her that she would make him happy if she would follow him to his new life, but that he did not think it advisable for either of them to nourish hope for a distant future and to bind themselves with a promise for an indefinite period.

'He was still hoping for a favourable reply to that letter, but the one that came was one his reason was happy with, not his heart. In a very elegant manner she released him from his word, without quite setting his heart free, and the note spoke of her own feelings in the same way; according to what her words said, she was free, but what they implied was that she was still bound.

'What is the point of piling on any more details? Ferdinand made haste to return to the quiet country area, where he had soon set up his factory. He was

steady and hardworking, all the more so as he was happily married to the good, natural girl we have already met and her old uncle did all he could to secure his domestic arrangements and make them as comfortable as possible.

'I got to know him in later years, surrounded by a numerous family of thriving children. He told me his story himself. As often happens to people who have significant experiences when they are young, those events had made such a deep impression on him that they had had a great influence on his life. Even as a mature man and father of a family he would occasionally forgo a pleasure, so as not to get out of practice in such a fine virtue, and his whole system of education seemed to consist in enabling his children to forgo something on the spur of the moment, as it were.

'Once at table, for example, in a way of which I could not initially approve, he forbade one of his boys to have a dish he was particularly fond of. To my amazement the boy remained cheerful, as if nothing special had happened, and his eldest children would sometimes, of their own accord, let a particularly fine piece of fruit or other titbit pass.

'Apart from that, though, I think I can say he allowed them everything and there was no lack of mischief in the house. He seemed indifferent to everything and allowed them almost unbounded freedom. Just once a week he would suddenly have the idea that everything had to be done on the dot: then the clocks would be regulated in the morning, they would all receive their orders of the day, there

were chores and games aplenty and no one was allowed to absent themselves for a second. I could spend hours recounting his discussions and comments on his strange method of upbringing. He would joke with me, as a Catholic priest, about my vows and used to maintain that everyone ought to take a vow of abstinence for himself and obedience to others; not to practise it always, he would add, but at the right time.'

The Baroness made some comments, adding that on the whole the priest's friend was probably right. In a country, too, everything depended on the executive; however reasonable the legislation was, it was no use to the state if the organs responsible for implementing it lacked power.

Luise leapt up and ran over to the window, for she had heard Friedrich ride into the courtyard. She went to meet him and led him back into the room. He seemed cheerful, even though he had come from scenes of misery and devastation, and instead of setting off on a precise description of the fire that had destroyed his aunt's house, he told them that it was certain that the desk there had been burnt at the same time as theirs had split with such a violent crack.

'At the very moment when the fire was already close to the room,' he said, 'the steward rescued a clock that was standing on the desk. As he carried it out, the works must have been affected and it stopped at half past eleven, so there is complete correspondence, at least as far as the time is concerned.'

The Baroness smiled, and the tutor pointed out

that the fact that two things happened at the same time did not prove there was a connection. On the other hand the idea of a link between the two incidents appealed to Luise, especially as she had received news of her fiancé, who was safe and sound. So once more they gave full rein to their imagination.

'Do you not,' Karl said to the old priest, 'have some fairy tale you can tell us? The imagination is a fine faculty, only I do not like to see it applied to things that have really happened. The amusing figures it creates are welcome when they are beings that belong to their own world; allied to reality it mostly produces nothing but monsters and is then, it seems to me, usually in conflict with common sense and reason. It should not, I feel, become attached to a subject, it should not try to force a subject on us; when it produces a work of art it should play on us, like music, move us inside ourselves in such a way that we forget there is something outside us producing that effect.'

'Do not,' said the old priest, 'go into greater detail about the demands you place on a product of the imagination. Part of our enjoyment of such works is that we enjoy them without making any demands on them; imagination itself cannot demand, it must wait for things to come as a gift. It makes no plans, it does not pursue a specific path, it is carried along on its own wings, and as it sweeps this way and that it, describes the most curious orbits, always changing direction, twisting and turning. Let me take my usual walk and bring back to mind the strange images that often amused me in earlier years. For this

evening I promise you a fairy tale that will remind you of everything and nothing.'

They were happy to let the old priest go, the more so as they all wanted to hear the news of what had happened from Friedrich.

THE FAIRY TALE

By the great river, which was swollen with heavy rain and had just burst its banks, the old ferryman lay sleeping in his tiny shack, tired from the exertions of the day. In the middle of the night he was woken by loud voices; he heard travellers wanting to be taken across.

When he came out, he saw two large will-o'-the-wisps hovering over his boat, which was tied up. They assured him they were in a great hurry and wished they were on the other side already. The old man wasted no time, pushed off and rowed them across the river with his usual skill, while the two strangers hissed at each other in an unknown and very rapid language, at times breaking out into loud laughter as they hopped up and down, from the sides of the boat onto the seats then onto the bottom and back again. 'The boat's rolling!' the old man called out. 'If you can't keep still it might capsize. Sit down you jack-o'-lanterns.'

The idea that they should sit still sent them into gales of laughter. They mocked the old man and darted about even more than before. He bore their rudeness with patience and soon reached the other side.

'Here's something for your pains,' the travellers shouted. They shook themselves and many gleaming gold coins fell into the damp boat.

'For heaven's sake, what are you doing?' the old

man cried. 'You'll bring down terrible misfortune on me. If one gold coin had fallen in the water, the river, which cannot bear that metal, would have risen up in fearsome waves and engulfed both me and my boat. And who knows what would have happened to you. Take your money back.'

'We cannot take anything back once we have shaken it off,' they replied.

'So you're leaving it to me,' the old man said, as he bent down and collected the gold coins in his cap, 'to gather them up and take them onto dry land to bury them.'

The will-o'-the-wisps had jumped out of the boat and the old man called to them, 'Where is my reward?'

'A man who refuses to take gold can work for nothing,' the will-o'-the-wisps cried.

'You should know that I can only be paid with fruits of the earth.

'With fruits of the earth? We despise them, we have never eaten them.'

'Still, I cannot let you go until you have promised to bring me three cabbages, three artichokes and three large onions.'

The will-o'-the-wisps tried to slip away, laughing and joking, but they felt themselves in some incomprehensible way fixed to the ground. It was the most uncomfortable feeling they had ever had.

The ferryman was already a long way off when they called out to him, 'Old man! Hey, old man! We've forgotten the most important thing.'

He was far away and did not hear them. He had let

his boat be carried down to a spot on the same side of
the river where he was going to bury the dangerous
gold in a mountainous region the water would never
reach. There he found an immense ravine between
high rocks, poured it in and rowed back to his shack.

In that ravine lived the beautiful green snake, who
was wakened from her sleep by the jingling of the
coins as they dropped down. Scarcely had she seen
the gleaming discs than she greedily devoured them,
carefully seeking out all those that had landed in the
bushes or the crevices in the rocks.

Scarcely had she swallowed them than she felt a
most pleasant sensation as the gold melted in her
entrails and spread throughout her body, and to her
delight she realised that she had become transparent
and glowing. She had long ago been told that this was
possible, but since she doubted whether the glow
would last, curiosity and the desire to be certain
about her future drove her out of the rocks to dis-
cover who had scattered the marvellous gold in
among them. With delight she admired herself, as she
crawled between the plants and bushes, and the
charming light she cast over the fresh foliage. All the
leaves seemed to be made of emerald, all the flowers
magnificently transformed.

It was in vain that she searched through the lonely
wilderness, but her hopes grew all the more when she
reached the plain and saw in the distance a radiance
that was similar to her own. 'At last I have found a
creature like me,' she cried, and hastened towards the
spot, ignoring the difficulties of crawling through
marsh and rushes. Although she preferred living in

125

dry mountain meadows and crevices in the high rocks, although she liked to eat spicy herbs and usually quenched her thirst with dew and fresh spring water, for the sake of the gold and hoping to find the splendid light, she would have done anything she was asked.

She was very tired by the time she reached a damp patch of rushes where our two will-o'-the-wisps were dancing to and fro, but she dashed over and greeted them, delighted to find she was kin to such charming gentlemen. The jack-o'-lanterns bobbed alongside her, skipped over her and laughed in their usual manner.

'Coz,' they said, 'you may belong to the horizontal line, but that doesn't matter. Of course, we're only related through the light. Look' – here the two flames sacrificed breadth for height and made themselves as long and slim as possible – 'see how well this slender length suits us gentlemen of the vertical line. Don't take it amiss, my friend, but which family can make a similar boast? As long as there have been will-o'-the-wisps, none of them has ever sat or lain down.'

The snake felt very uncomfortable in the presence of these relations for, however high she raised her head, she sensed she would have to let it back down onto the ground before she could go anywhere. At first she had been delighted with herself in the dark grove, but in the presence of these cousins her glow seemed to diminish with every second. Indeed, she feared it might eventually fade away completely.

Uncertain what to do, she hurriedly asked the two

126

gentlemen whether they might not be able to tell her where the shining gold had come from that had fallen into the chasm just now. She thought it must have been a shower of gold trickling straight down from the heavens. The will-o'-the-wisps laughed and shook, spraying a large number of gold coins round them. The snake quickly went to get them and swallow them up.

'Tuck in, Coz, tuck in,' said the amiable gentlemen, 'there's more where that came from,' and they shook themselves very rapidly a few more times, so that the snake could hardly get the precious food down quickly enough. Her glow began to increase visibly. Once more she was shining most gloriously, while the will-o'-the-wisps had grown fairly thin and small, without, however, losing anything of their good mood.

'I'm eternally grateful to you,' said the snake when she had managed to get her breath back after her meal. 'Ask of me whatever you like, if it's in my power, I'll do it.'

'Excellent!' cried the will-o'-the-wisps. 'Tell us, where does Fair Lily live? Take us as quickly as possible to the palace and garden of Fair Lily. We're dying with impatience to throw ourselves at her feet.'

'That is something,' said the snake with a deep sigh, 'which I cannot do for you straight away. Fair Lily lives on the other side of the water.'

'On the other side of the water! And we had ourselves ferried across on this stormy night! How cruel is the river that separates us! Wouldn't it be possible to call the old man back over?'

'You would be wasting your breath,' replied the snake. 'Even if you were to meet him on this bank, he would not take you. He is allowed to ferry anyone across to this side, but can take no one across to the other side.'

'We've made a fine mess of things. Is there no other way of getting across the water?'

'There are several, only not at this hour. I can take you across myself, but not until midday.'

'That is a time at which we are not very keen on travelling.'

'In that case you can go over in the evening on the giant's shadow.'

'How does that work?'

'The big giant, who lives not far from here, can do nothing with his body. His hands can't lift up a straw, his shoulders wouldn't carry a bundle of kindling, but his shadow can do a lot, can do everything. That is why he is at his most powerful at sunrise and sunset. You just have to sit on the neck of his shadow in the evening and the giant will gently walk towards the river bank and his shadow will carry you across. However, should you go at midday to that part of the woods where the bushes come close to the bank, then I can take you across and introduce you to Fair Lily. If, on the other hand, you prefer to avoid the midday heat, then all you need to do is to go and see the giant in that rocky hollow towards evening, I'm sure he'll be most willing to oblige you.'

The two young gentlemen sketched a bow and left. The snake was happy to see them go, partly so that she could enjoy her own light and partly because it

128

gave her the opportunity to satisfy a curiosity she had long found strangely tormenting.

At one place in the rocky ravines, which she often crawled up and down, she had made an odd discovery. Although she was compelled to crawl through these chasms without light, she could perfectly well distinguish objects by feel. Everywhere she was accustomed to finding only irregular products of nature; now she would be winding her way through the jagged spikes of large crystals, now she would feel the hooks and hairs of pure silver and she would bring the occasional precious stone out into the light. But, to her great astonishment, in a rock that was enclosed all round she had felt objects which suggested they had been fashioned by human hand: smooth walls she could not climb, sharp, regular edges, shapely columns and, what she found strangest, human statues she had wound herself round several times and which she concluded must be of bronze or perfectly polished marble. She wanted to subject all these impressions to the sense of sight, in order to confirm what she suspected. She believed she was now capable of illuminating this marvellous underground vault with her own light, hoping at last to become fully acquainted with these strange objects. She hurried off and quickly found the crevice through which she usually slipped into the shrine.

Once she was there, she looked round with curiosity, and although her light could not illuminate all the objects in the dome, the ones closest to her were clear enough. In amazement and awe she looked at a shining niche in which there was the statue of a

venerable king of pure gold. The scale of the statue was larger than life-size, but the figure was of a man who was short rather than tall. His well-proportioned body was wrapped in a simple cloak and his hair held together by a circlet of oak leaves.

Scarcely had the snake seen this venerable likeness, than the king spoke and asked, 'Where have you come from?'

'From the ravines where the gold lives,' the snake replied.

'What is more magnificent than gold?' the king asked.

'Light,' replied the snake.

'What is more refreshing than light?' he asked.

'Conversation,' she replied.

While they were talking, she had seen out of the corner of her eye another magnificent statue in the next niche. In it was a silver king, tall and rather slim in stature. His body was covered in an elaborate garment, his crown, belt and sceptre decorated with precious stones. His face bore an expression of serene pride and he seemed to be about to speak, when a dark vein running through the marble wall suddenly became bright, spreading a pleasant light throughout the whole temple. In this light the snake could see the third king, a massive bronze figure sitting there, leaning on his club, wearing a laurel wreath and looking more like a rock than a man. She was about to turn round to look at the fourth, who was standing a great distance from her, but the wall opened as the vein in the marble blazed up like a flash of lightning and disappeared.

The snake's attention was drawn to a man of medium height who came out. He was dressed as a peasant and carried a small lamp in his hand. Its still flame was pleasant to look at and in some miraculous way it lit up the whole dome without casting a single shadow.

'Why do you come, since we have light?' the golden king asked.

'You know that I may not illuminate the darkness.'

'Will my kingdom come to an end?' the silver king asked.

'In the latter days or never,' replied the old man.

In a loud voice the bronze king started his questions. 'When will I stand up?'

'Soon,' replied the old man.

'With whom am I to join forces?' the king asked.

'With your elder brothers,' said the old man.

'What will become of the youngest?' asked the king.

'He will sit down,' said the old man.

'I am not tired,' cried the fourth king in a hoarse, stuttering voice.

While the others were talking, the snake had crawled quietly round the temple, had looked at everything and was now gazing at the fourth king from close to. He was standing, leaning against a column, and his considerable figure was ponderous rather than handsome. But it was not easy to make out what metal he had been cast from. Looked at closely, it was a mixture of the metals from which his three brothers were made, only when he had been

cast, the three materials did not seem to have fused properly. Irregular veins of gold and silver ran through a mass of bronze, giving the whole an unpleasant look.

Meanwhile the golden king was saying to the man, 'How many secrets do you know?'

'Three,' replied the old man.

'Which is the most important?' asked the silver king.

'The open secret,' replied the old man.

'Will you reveal it to us?' asked the bronze king.

'As soon as I know the fourth,' said the old man.

'What do I care!' muttered the composite king to himself.

'I know the fourth secret,' said the snake, going over to the old man and hissing something in his ear.

'The time is nigh!' the old man cried in a mighty voice.

The temple resounded, the metal statues rang, and in that same moment the old man sank down to the west and the snake to the east, and each passed at great speed through the rocky chasms.

All the passageways that the old man strode through immediately filled behind him with gold, for his lamp had the magical ability to turn all stones into gold, all wood into silver, dead animals into precious stones, and to destroy all metals. However, to produce this effect, it had to shine alone. If there was another light beside it, it just had the effect of a beautiful radiance and all living beings were refreshed by it.

The old man went into his hut, that was built

against the hill, and found his wife greatly distressed. She was sitting by the fire crying and refused to be comforted.

'How unhappy I am,' she cried, 'I wish I had never let you go out today.'

'What is the matter?' asked the old man calmly.

'Hardly had you left,' she said, sobbing, 'than two importunate travellers appeared at the door. They seemed proper, decent people, so I was incautious enough to let them in. They were clothed in light flames, you could have taken them for will-o'-the-wisps. Scarcely were they in the house than they started to flatter me in the most shameless manner and were so importunate it makes me blush to think of it.'

'Well,' said the man with a smile, 'I imagine the gentlemen were joking. Given your age, they should have stuck to the usual courtesies.'

'Age?! Age?!' cried he woman. 'Why do you keep going on about my age? How old am I, anyway? The usual courtesies! I know what I know. And just have a look at the walls. Do you see the old stones I haven't set eyes on for a hundred years? They licked off all the gold, you won't believe how quickly they did it, and they kept telling me it tasted much better than common gold. Once they had cleared the walls they seemed in a very good mood; in a short time they had certainly grown much larger, broader and glossier. Then they started their tricks again, stroking me and calling me queen. They shook themselves and a lot of gold coins went bouncing all over the place, you can still see them shining under the bench

there. But then disaster struck! Our pug ate some and, look, there he is, lying dead by the fire, the poor thing. I can't get over it. I only noticed once they had gone, otherwise I wouldn't have promised to pay their debt to the ferryman.'

'What do they owe him?' the old man asked.

'Three cabbages,' said the woman, 'three arti-chokes and three onions. I promised to take them down to the river at daybreak.'

'You can do them the favour,' said the old man, 'they'll be of service to us again when the time comes.'

'Whether they'll be of service ot not, I couldn't say, but I promised and swore I'd do it.'

By this time the fire had died down. The old man spread ashes over the cinders, and put the shining gold coins away so that his lamp was once more the sole light, shining in all its glory. The walls were covered with gold and the pug was transformed into a most beautiful onyx. The alternation of brown and black colours in the precious stone made it into a rare work of art.

'Take your basket,' the old man said, 'and put the onyx in it. Then put the three cabbages, the three artichokes and the three onions round it and take them to the river. Get the snake to carry you across around midday and go to see Fair Lily. Give her the onyx, she will touch it and bring it back to life, just as she kills all living things when she touches them. She will find it a loyal companion. Tell her not to be sad, her release is at hand, she can regard the great-est misfortune as the greatest good fortune, for the time is nigh.'

When day broke, the old woman took up her basket, balanced it on her head and set off. The rising sun shone brightly across the river, which glistened in the distance. The woman walked slowly, for the basket weighed down on her. But it was not the onyx which was so heavy. She did not feel any dead things she carried, for then the basket would rise up and hover above her head. But carrying fresh vegetables or a small living animal she found extremely cumbersome.

She had been walking along for a while in an ill-humour when she suddenly halted in alarm. She had almost trodden on the giant's shadow, which stretched over the level ground to where she was. Only now did she see the mighty giant getting out of river, where he had been bathing, and she did not know how to avoid him. As soon as he noticed her, he began to address her in playful tones and his shadow's hands immediately felt in her basket. With swift and nimble fingers they took out one cabbage, one artichoke and one onion, and carried them to the mouth of the giant, who then continued up the river, leaving the way free for the woman.

She wondered whether she ought to go back and replace the missing vegetables from her garden. She walked on, musing over these doubts, and soon reached the bank of the river. For a long time she sat there, waiting for the ferryman, whom she eventually saw crossing over with a strange traveller. A handsome, noble young man she could not take her eyes off stepped out of the boat.

'What have you brought?' the old man called out.

'It is the vegetables the will-o'-the-wisps owe you,' answered the woman, pointing to the things in her basket.

When the old man discovered there were only two of each kind, he turned sullen and told her he could not accept them. The woman begged him, telling him she could not go back home at the moment and that the burden on the road she had before her would be heavy. He stuck by his refusal, assuring her that the decision was not in his hands.

'I must leave the things that are due to me together for nine hours, and I am not allowed to take anything before I have handed over a third part to the river.'

After much toing and froing, the old man finally said, 'There is one way. If you will guarantee to give the river its share and acknowledge that you are in its debt, then I will take the six vegetables, but there is some danger in this.'

'If I keep my word, surely I will not be in any danger?'

'Not the slightest. Put your hand in the river,' the old man went on, 'and promise you will pay the debt within twenty-four hours.'

The old woman did so, but imagine her horror when she took her hand out of the water and saw that it was pitch-black. She remonstrated vehemently with the old man, protesting that her hands had always been the most beautiful thing about her and that, despite all her hard work, she had always managed to keep them fine and white. Indignantly she inspected the hand and exclaimed in despair,

'This is even worse! I can see that it has shrunk, it is much smaller than the other.'

'At the moment it just looks like that,' said the old man, 'but if you do not keep your word, it can come true. Your hand will gradually wither away and eventually disappear completely, without your losing the use of it. You will be able to do everything with it, only no one will see it.'

'I'd prefer it to be useless but that no one could see that,' said the old woman. 'However, no matter, I'll keep my word in order to get rid of this black skin and this worry as quickly as possible.'

With that she hastily took her basket, which rose up above her head of its own accord and hovered over it, and hurried after the young man, who was walking slowly along the riverbank, deep in thought. His magnificent figure and his strange dress had made a deep impression on the old woman.

He wore a gleaming breastplate, which revealed the movements of all parts of his handsome body, and a cloak of purple hung about his shoulders. He went bareheaded, his brown hair flowing in beautiful locks, and his fair face was exposed to the rays of the sun, as were his shapely feet. Barefoot, he walked calmly over the hot sand, profound sorrow seeming to make him oblivious to all external impressions.

The garrulous old woman tried to involve him in conversation, but he only gave her curt replies so that eventually, despite his good looks, she wearied of speaking to him in vain and bade him farewell, saying, 'You're going too slowly for me, sir, I mustn't be too late to cross the river on the green snake and

take this excellent present from my husband to Fair Lily.'

With those words she hurried off, and just as quickly the handsome youth pulled himself together and hurried along behind her.

'You're going to Fair Lily!' he exclaimed. 'Then we're going the same way. What is the present you are carrying?'

'Sir,' replied the woman, 'it is not right, after warding off my questions with such curt answers, to show such a lively interest in my secrets. However, if you are willing to agree to an exchange and let me hear your story, I will be happy to tell you about me and my present.'

They soon came to an agreement. The old woman told him all about herself and what had happened to the dog, allowing him to see the marvellous present.

He picked the work of art, that was also a work of nature, out of the basket and held the pug, which seemed to be sleeping peacefully, in his arms.

'Fortunate animal!' he exclaimed. 'You will feel the touch of her hands, you will be brought to life by her, instead of fleeing her so as not, as a living beast, to suffer a sad fate. But what am I saying? Sad? Is it not much more wretched and doleful to be paralysed by her very presence than it would be to die by her hand?

'See,' he said to the old woman, 'what a wretched state I have come to in my years. This breastplate, which I wore with honour in war, and this purple, which I tried to be worthy of by ruling wisely, are all that fate has left me, the one a useless burden, the

other a trifling adornment. Crown, sceptre and sword
are gone, leaving me as naked and destitute as any
other mortal. So baleful is the effect of her beautiful
blue eyes that they suck the strength from all living
beings, and all those who are not killed by the touch
of her hand feel they are condemned to walk the
world as living shadows.'

He continued to complain in this manner, not sat-
isfying the old woman's curiosity at all, since she
wanted to hear the story of his life, not just his feel-
ings. She learnt neither the name of his father, nor of
his kingdom. He kept stroking the hard pug dog,
which the sunshine and the youth's warm breast had
warmed so that it felt as if it were alive. He asked
many questions about the man with the lamp and
the effects of its holy light, and seemed to have high
hopes of what it might in future do for his sad state.

While they were thus talking, they saw in the dis-
tance the majestic arch of the bridge, which
stretched from one bank to the other, shimmering
marvellously in the light of the sun. They were both
astonished, for they had never seen this structure
looking so magnificent.

'What!' cried the prince, 'Was it not beautiful
enough before when it looked to our eyes as if it were
built of jasper and quartz. Must we not fear to set
foot on it, now that it appears to be built of a most
graceful combination of emerald, chalcedony and
chrysolite?'

Neither of them knew of the change that had
happened to the snake, for the snake it was, which
arched over the river every midday and stood there in

the form of a bridge. The two travellers stepped onto it with awe and crossed over in silence.

They had barely reached the other side when the bridge started to move and vibrate. Soon it touched the surface of the water and the green snake was gliding along behind the travellers on dry land in her original shape. Hardly had the two of them thanked her for allowing them to cross the river on her back than they realised there must be several others apart from the three of them in the company. However, they could not see these others with their eyes. They heard hissing beside them, which the snake answered with a hissing of her own. They pricked up their ears and eventually managed to hear the following:

'First of all,' said alternating voices, 'we will have a look round Fair Lily's park incognito and we beg you to present us to that perfect beauty at nightfall, as soon as we are at all presentable. You'll find us on the shore of the great lake.'

'Agreed,' the snake replied and the hissing noise gradually faded away.

Now our three travellers discussed in what order they should appear before the the fair one. However many persons there might be around her, they could only come and go singly, if they did not want to suffer severe pain.

The woman with the metamorphosed dog in her basket was the first to approach the garden and seek out her friend, who was easy to find, as she was at that moment singing to her harp. At first the delightful music appeared as rings on the calm surface of the lake then, like a gentle breeze, it set the grass and

bushes swaying. She was sitting on an enclosed lawn, in the shadow of a magnificent group of various kinds of trees and once more delighted the eye, ear and heart of the old woman as soon as she saw her. As she approached Lily, entranced, she told herself that the fair one had become even more beautiful since she had last seen her. When she was still some way away, the woman greeted this most charming of girls, singing her praises:

'What a delight to look on you! What a sky your very presence spreads round you! How charmingly the harp rests in your lap, how tenderly your arms embrace it, how it seems to long for your breast and what delicate sounds it makes at the touch of your slender fingers! Thrice fortunate the youth who could take its place!'

She approached as she spoke. Fair Lily opened her eyes, took her hands off the harp and said, 'Do not dishearten me with ill-timed praise, it only makes me feel my misfortune all the more. Look, there lies my poor canary, that used to accompany my songs in the most charming fashion, dead at my feet. It had been taught to sit on my harp and carefully trained not to touch me. Today when, refreshed by sleep, I started to sing a calm morning song and my little songster sounded his harmonious notes more merrily than ever, a hawk swept past over my head. Terrified, the poor little creature fled to my bosom and in that same moment I felt its last convulsions as life departed. The predator, struck by my glance, is crawling laboriously along by the river there, robbed of the power of flight, but what use to me is his

punishment. My darling is dead and his grave will only increase the sad foliage of my garden.'

'Take heart, Fair Lily,' said the woman, wiping away a tear the unhappy girl's tale had brought to her own eye, 'and summon up all your courage. My husband sends word that you should moderate your grief and regard the greatest misfortune as the harbinger of the greatest good fortune, for the time is nigh. Truly,' the old woman went on, 'strange things are happening in the world. Just see my hand, how black it has become. Truly, it is already much smaller, I must hurry before it disappears completely. Why did I do the will-o'-the-wisps a favour, why did I meet the giant and why did I dip my hand in the river? Could you not give me a cabbage, an artichoke and an onion? If you can, I will take them to the river and my hand will be as white as it was before, so white I could almost hold it next to yours.'

'Cabbages and onions you will find, but artichokes you will look for in vain. None of the plants in my large garden has either flowers or fruits. But every twig I break off and plant on the grave of one of my darlings immediately puts out leaves and shoots up. It is with sorrow that I have watched all these bushes, these thickets and copses grow. These green-capped pines, these cypresses like tall obelisks, these colossal oaks and beeches were all tiny twigs I planted in otherwise barren ground as a sad memorial.'

The old woman had paid little attention to all this. She just kept staring at her hand which, in the presence of Fair Lily, seemed to be growing blacker

and blacker, and smaller by the minute. She was about to take her basket and hurry off when she remembered she had forgotten the most important thing. She immediately took out the metamorphosed dog and put it down on the grass not far from the feet of the beautiful girl.

'My husband,' she said, 'sends you this token. You know that you can bring this precious stone to life by touching it. I am sure this charming, loyal creature will give you much delight, and my sorrow at losing it can only be eased by the knowledge that it is yours.

Fair Lily looked at the charming creature with pleasure and, so it seemed, amazement. 'There are many portents appearing in conjunction,' she said, 'which gives me some hope. But, oh!, is it not our nature, when many misfortunes combine, to deceive ourselves into thinking the best is close at hand?

'What use to me are all these wondrous signs?
My friend's black hand? The death of my canary?
The onyx pug? – Is anything so fine?
And was it not the Lamp that sent it for me?

'Why are Fair Lily's days devoid of mirth?
Has life but only grief and pain to give her?
Why does no bridge traverse the river's girth?
Why is no temple built beside the river?'

It was with impatience that the woman listened to this song, which Fair Lily accompanied with the pleasant tones of her harp and which would have delighted anyone else. She was about to say goodbye

when she was once more held back, this time by the arrival of the green snake, who had heard the last lines of the song and therefore immediately spoke words of encouragement to Fair Lily.

'The prophecy of the bridge is fulfilled!' she exclaimed. 'Just ask this good lady how magnificent the arch now looks. What was once opaque jasper, what was merely quartz, where the light at most shimmered through at the edges, is now changed into transparent precious stone. No beryl is so clear, no emerald has such beautiful colour.'

'I congratulate you,' said Lily, 'but you must forgive me if I still do not believe the prophecy has been fulfilled. Only travellers on foot can cross the high arch of your bridge, yet we were promised horses and carriages and all kinds of travellers would be able to go over the bridge in both directions at the same time. Was there not a prophecy that great pillars will rise up out of the river?'

The old woman, still with her eyes fixed on her hand, broke in at this point to say farewell.

'Wait just one moment,' said Fair Lily, 'and take my poor canary with you. Ask the Lamp to change it into a beautiful topaz, then I will bring it back to life by touching it. Together with your pug dog, it will be my dearest pastime. But hurry as quickly as you can, for once the sun has set, horrible decay will take hold of the poor creature and destroy the fair proportions of its body for ever.'

The old woman placed the little corpse among some soft leaves at the bottom of her basket and hurried off.

'However that may be,' said the snake, taking up the interrupted conversation, 'the temple is built.'

'But it is still not beside the river,' replied Lily.

'It is still deep within the bowels of the earth,' said the snake. 'I have seen the kings and spoken with them.'

'But when will they arise?'

The snake replied, 'I heard the great words echo round the temple: The time is nigh.'

A pleasantly cheerful expression spread over the face of Fair Lily. 'That is the second time,' she said, 'that I have heard those happy words today. When will the day come when I hear them three times?'

She stood up and immediately a charming girl came out of the bushes and took her harp. She was followed by a second, who folded up the carved ivory chair Lily had been sitting on and took the silver cushion under her arm. A third appeared with a large pearl-embroidered parasol in case Lily should need it for a walk. These three girls were more beautiful and charming than one could say, yet they merely emphasised the beauty of Fair Lily, since everyone had to admit there was no comparison between them.

Meanwhile Fair Lily had been looking fondly at the pug dog. She bent down and touched it, and immediately it jumped up. Bright-eyed, it looked around, ran up and down, then finally dashed over to give its benefactor a most affectionate greeting. She took it in her arms and pressed it to her.

'Even though you are cold,' she cried, 'even though there is only a half life at work inside you, you are still welcome. I will love you tenderly, play

charming games with you, give you affectionate caresses and press you to my heart.'

She put it down, chased it away, called it back, played such charming games with it and frolicked on the grass with it in such a lively and innocent fashion that her joy would have filled anyone watching her with fresh delight, just as a short time before her grief would have wrung pity from any heart.

This merriment, these charming frolics were interrupted by the arrival of the sad youth. He approached, looking as we have already seen him, except that the heat of the day seemed to have made him even wearier and in the presence of the one he loved he grew paler with every second. He was carrying the hawk on his hand. It sat there, as calm as a dove, its wings folded.

'It does not show your affection for me,' Lily cried out to him, 'to bring the hated animal into my sight, the monster that killed my little songster today.'

'Do not chide the unfortunate bird,' the youth replied. 'Rather blame yourself and fate, and allow me to remain with my companion in misery.'

While they were speaking, the pug dog continued to tease Fair Lily and she responded in the most affectionate manner to her transparent pet. She clapped her hands to drive it away, then ran after to drag it back. She tried to catch it when it ran off, and chased it away when it tried to press itself on her. The youth watched silently and with growing frustration. Finally, when she picked up the ugly beast, which he found quite repulsive, pressed it to her white bosom and kissed its black snout with her

divine lips, he lost patience and cried out, in the depths of despair:

'Must I, condemned by a sad fate to live, perhaps for ever, before you in a separate present, must I, who through you have lost everything, even myself, look on and see how such an unnatural abomination can bring you pleasure, hold your affection and enjoy your embrace. Must I measure out even more days just walking up and down, retracing the sad circuit across the river and back? No, there is still a spark of my former courage left in my breast, let it blaze up in one final flame! If stones may rest on your bosom, then let me be turned to stone. If your touch can kill, then let me die at your hand.'

With these words he made a violent movement. The hawk flew up from his hand as he flung himself at Fair Lily. She stretched out her hands, to ward him off, only to touch him all the sooner. Consciousness left him, and it was with horror that she felt the handsome burden on her breast. With a cry, she drew back and the sweet youth fell from her arms, lifeless, to the ground.

The misfortune had happened! Lily stood there motionless, her gaze fixed on the lifeless corpse. For a moment her heart seemed to stop beating and there were no tears in her eyes. In vain the pug tried to elicit an affectionate response, with her friend her whole world had died. Her mute despair did not seek help, for it knew no help.

The snake, on the other hand, was all the busier, she seemed to have rescue in mind and, indeed, her strange movements did at least manage to delay the

terrible immediate consequences of the misfortune for some time. With her supple body she made a wide ring round the corpse, grasped the end of her tail in her teeth and lay there, unmoving.

It was not long before one of Lily's lovely servants came with the ivory folding chair and gently urged Fair Lily to sit down. Soon the second servant appeared, carrying a fiery-red veil with which she more adorned her mistress's head than covered it. The third handed her the harp, and hardly had she embraced the magnificent instrument and drawn a few notes from the strings than the first servant returned with a bright round mirror, placed herself opposite Fair Lily, caught her eye and showed her the most delightful image to be found in nature. Sorrow increased her beauty, the veil her charms, the harp her grace, so that however much one hoped to see a change in her sad situation, one was equally desirous to retain for ever the image of her as she was at that moment.

With a quiet look at the mirror, she first drew melting tones from the strings, then her grief seemed to grow and the strings responded furiously to her sorrow. Once or twice she parted her lips to sing, but her voice failed her. Soon, however, her grief dissolved in tears. Two girls came to her aid and took her in their arms, the harp sank from her lap and the nimble servant only just managed to catch the instrument and put it on one side.

'Who will bring the man with the lamp to us before the sun sets?' the snake hissed, softly but audibly. The girls looked at each other, and Lily's tears

increased. At that moment the woman with the basket returned, out of breath.

'I'm lost!' she cried, 'I'm maimed! Look, my hand has almost completely withered away. Both the ferryman and the giant refused to carry me across because I'm still in debt to the water. I offered them a hundred cabbages and a hundred onions, but in vain, all they want is three of each and there aren't any artichokes round here.'

'Forget your own worries,' said the snake, 'and try to help us here, perhaps it will help you too. Hurry, as fast as you can, and find the will-o'-the-wisps. It's still too light to see them, but you might hear their laughing and fluttering. If they hurry, the giant will still carry them across the river and they can find the man with the lamp and send him here.'

The woman hurried as fast as she could and the snake seemed to be awaiting her return with the man as impatiently as Lily. Unfortunately, by this time the rays of the setting sun were gilding just the very tops of the trees in the grove and long shadows stretched across lake and meadow. The snake wriggled impatiently and Lily was bathed in tears.

In her desperation, the snake kept looking round everywhere, for she was afraid the sun might set at any moment, allowing decay to break through the magic ring and attack the handsome youth irrevocably. Finally, high in the sky she saw the hawk with its crimson feathers, its breast catching the last rays of the sun. She quivered with joy at this good sign, nor was she mistaken, for shortly after they saw the

man with the lamp glide across the lake, as if he were
on skates.

The snake did not change her position, but Lily
stood up and called out to him, 'What good spirit has
sent you at the very moment when we want you and
need you so much?'

'The spirit of my lamp drives me here,' the old
man replied, 'and the hawk guides me. My lamp
sends out sparks when someone needs me and I look
up in the air for a sign. Some bird or meteor will show
me the direction in which I must go. Be calm, fair
maiden. I do not know if I can help you. One person
cannot achieve anything alone, only someone who
unites with many at the right moment. Let us play
for time and still hope.'

'Keep the ring closed,' he went on, turning to the
snake. He sat down on a mound beside her and cast
the light of his lamp on the dead body. 'Bring that
sweet little canary as well and place it in the ring.'
The girls took the tiny corpse out of the basket,
which the old woman had left there, and did as the
man had commanded.

By this time the sun had gone down and as the
darkness thickened not only the snake and the lamp,
each in their own way, started to shine, Lily's veil,
too, gave off a gentle light, colouring her pale cheeks
and white dress with infinite grace, like the delicate
pink of dawn. They looked from one to the other in
silent contemplation, worry and grief tempered by
sure hope.

The appearance of the old woman accompanied by
the two lively flames was, therefore, not unwelcome.

Since they were last seen, the will-o'-the-wisps must have been very liberal with their gifts, for they had become extremely thin again, but they were all the more courteous towards the princess and the other women. They made the usual compliments with the greatest self-assurance and elegance of expression. They seemed particularly receptive to the charm the glowing veil spread over Lily and her companions. The young women lowered their eyes modestly and the will-o'-the-wisps' praise of their beauty did indeed enhance it. Everyone was calm and content, apart from the old woman. Despite her husband's assurance that her hand would not wither away further, as long as it was in the light of his lamp, she said more than once that if things went on as they had, the fair member would disappear completely before midnight.

The old man with the lamp had been listening carefully to what the will-o'-the-wisps were saying and was pleased that their conversation had amused Lily and cheered her up.

Before they knew it, midnight had actually arrived. The old man looked up at the stars, then started to speak.

'We have come together at a propitious hour,' he said. 'Let each of us go to his task, let each do his duty, and general happiness will absorb individual cares, just as individual joys are swallowed up in general misfortune.'

After he had spoken, a wonderful sound arose, for all those present talked to themselves, saying out loud what they had to do. Only the three girls were

silent. They had fallen asleep, one beside the harp, the other beside the parasol and the third beside the chair, but no one could blame them, since it was very late. After a few brief courtesies to the servants, the two flickering youths had addressed themselves to Lily alone, as the fairest of them all.

'Take the mirror,' said the old man to the hawk, 'use it to reflect the light from up in the sky and awaken the sleeping girls with the first rays of the sun.'

The snake now started to move, opened the ring and slowly set off in great loops for the river. The two will-o'-the-wisps followed her with solemn tread, you would have taken them for the most serious of flames. The old woman and her husband took hold of the basket, whose soft light had hardly been noticed until now, and pulled at it from either side. It grew bigger and bigger, brighter and brighter. They put the body of the youth in it and placed the canary on his chest. The basket rose up and hovered over the head of the old woman, who followed close behind the will-o'-the-wisps. Fair Lily picked up the pug dog and followed the old woman. The man with the lamp brought up the rear and the countryside around was illuminated in the most strange manner by all these different lights.

But the company were no less full of admiration when, on reaching the river, they saw a magnificent arch sweeping over it, by which the helpful snake made a glittering path for them. Whereas by day they had admired the transparent jewels the bridge appeared to be made of, at night they were amazed

at its magnificent luminosity. The top of the bright
curve stood out sharply against the dark sky, whilst
underneath sprightly rays flared towards the centre,
showing the mobile stability of the structure. The
company crossed slowly and the ferryman, looking out
of his hut in the distance, stared in astonishment at
the luminous arch and the strange lights crossing it.

Scarcely had they reached the other side than the
arch began to sway in snakelike waves and sink down
towards the water. Soon afterwards the snake came
onto the land, the basket returned to the ground and
the snake made its ring around the youth again. The
old man leant forward and asked, 'What have you
decided?'

'To sacrifice myself, before I am sacrificed,' the
snake replied. 'Promise me you will leave no stone on
land.'

The old man promised and then said to Fair Lily,
'Touch the snake with your left hand and your
beloved with your right.'

Lily knelt down and touched the snake and the
dead body. At once the latter seemed to come back to
life. He moved in the basket, he even straightened up
until he was sitting. Lily was about to embrace him,
but the old man held her back, instead helping the
youth to stand up and guiding him as he stepped out
of the basket and the ring.

The youth stood there and the canary fluttered
onto his shoulder. Life had returned to both of them,
but not the spirit. Lily's handsome lover had his eyes
open, yet could not see, at least he appeared to be
looking at everything and not responding. Hardly

had their amazement at this subsided than they noticed the strange change that had come over the snake. Her beautiful slender body had disintegrated into thousands and thousands of shining precious stones. The old woman had tried to pick up her basket and had carelessly knocked against her. There was nothing of the snake's shape to be seen any more, just a beautiful ring of shining precious stones in the grass.

The old man immediately set about putting the stones in the basket, in which task his wife had to help him. Together they carried the basket to a high place on the bank of the river and poured the whole contents into the water, not without some protest from the fair maids and his wife, who would have liked to have chosen a few items for themselves. The stones floated along with the current, like glittering, shining stars, and they could not tell whether they vanished in the distance or sank to the bottom.

'Gentlemen,' said the old man, turning respectfully to the will-o'-the-wisps, 'now I will show you the way and will open up the path. You, however, will do us a great service, if you open the gates of the shrine for us. This time we must enter by them, and no one apart from you can unlock them.'

The will-o'-the-wisps made a respectful bow and stood back. The man with the lamp led the way into the rock, which opened up before him; the youth followed, walking like an automaton; Lily, silent and uncertain, stayed some way behind him; the old woman was unwilling to keep back and stretched out her hand so that her husband's lamp could shine on

it; finally came the will-o'-the-wisps, leaning the tips of their flames together, apparently talking to each other.

They had not gone far before they found themselves facing a large, bronze door, the two parts of which were closed with a golden lock. The old man immediately called over the will-o'-the-wisps, who needed little encouragement to start burning away the lock and bolt with their sharpest flames.

The bronze rang out as the doors quickly sprang open and the statues of the kings appeared in the shrine, illuminated by the light of the will-o'-the-wisps as they entered. Everyone bowed before the venerable monarchs, the will-o'-the-wisps in particular performing a multiplicity of elaborate bows.

After a pause the golden king asked, 'Where have you come from?'

'From the world,' the old man replied.

'Where are you going?' the silver king asked.

'Out into the world,' the old man said.

'Why have you come to us?' the bronze king asked.

'To accompany you,' the old man said.

The composite king was just about to speak when the golden king said to the will-o'-the-wisps, who had come too close to him, 'Keep away from me, my gold is not for the likes of you to savour.'

At that they turned to the silver king and nestled up to him, the reflection of their yellowish light giving a beautiful sheen to his robe.

'You are welcome,' he said, 'but I cannot feed you. Go and eat your fill elsewhere, then bring me your light.'

They left him and slipped past the bronze king, who seemed not to notice them, towards the composite king.

'Who will rule the world?' the latter cried, stuttering.

'The one who stands on his feet,' the old man replied.

'That is me!' the composite king said.

'It will be revealed,' said the old man, 'for the time is nigh.'

Fair Lily threw her arms round the old man and gave him a heartfelt kiss. 'Holy Father,' she said, 'I give you a thousand thanks, for now I have heard those propitious words for the third time.'

Hardly had she finished than she clutched the old man even more tightly, for the ground under their feet had started to sway. The old woman and the youth held on to each other; only the mercurial will-o'-the-wisps did not notice anything.

They could clearly feel that the whole temple was moving, like a ship slowly leaving harbour after the anchor has been weighed. The depths of the earth seemed to open up before it as it passed through. It did not hit anything, no rock was in its way.

For a few moments fine rain seemed to be trickling in through the opening in the dome. The old man held Fair Lily tighter and said to her, 'We are under the river, soon we will reach our goal.' Not long afterwards they thought they were standing still, but they were wrong. The temple was rising.

Now a strange thunderous noise came from above their heads. With much crashing, a crooked mass of

planks and beams started to pour in through the opening in the dome. Lily and the old woman leapt to the side, the man with the lamp grasped the youth and stood still. The ferryman's little hut – for that was what it was that the temple, as it rose, had lifted from the ground and swallowed up – gradually sank, covering the youth and the old man.

The women screamed out loud and the temple shuddered, like a ship unexpectedly going aground. Bewildered, the two women went round and round the hut in the semi-dark. The door was locked and no one answered their knocking. They knocked louder and were no little surprised when the wood started to resonate. The power of the enclosed lamp was turning the hut into silver from the inside out. It was not long before its shape began to change as well. The precious metal abandoned the haphazard forms of the planks, posts and beams, and expanded into a magnificent shell of embossed work. Now there was a magnificent small temple standing inside the large one or, if you like, an altar, worthy of the temple.

By an inside staircase, the noble youth went up onto the top. The man with the lamp lit his way and another seemed to be supporting him. He appeared wearing a short white robe and carrying a silver oar in his hand. He was immediately recognisable as the ferryman, the former occupant of the transformed hut.

Fair Lily climbed the outside steps, which led up from the temple onto the altar, but she still had to remain at a distance from her beloved. The old woman, whose hand had grown smaller and smaller

while the lamp was hidden, cried, 'Am I to be plunged into misery after all? With all these miracles, is there no miracle to save my hand?'

Her husband pointed to the open door and said, 'Look, day is breaking, hurry and bathe in the river.'

'What a suggestion!' she cried. 'Am I to become completely black and disappear completely? Remember, I have not yet paid my debt.'

'Go,' said the old man, 'and follow my advice. All debts have been paid.'

The old woman hurried off and at that moment the light of the rising sun struck the cornice at the top of the dome. The old man stepped between the youth and the maid and cried out in a loud voice, 'They are three that rule here on earth: wisdom, appearances and force.' At the first of the words the golden king stood up, at the second the silver king, and at the third the bronze king slowly raised himself, as the composite king suddenly sat down clumsily.

Despite the solemnity of the moment, all those who saw him could hardly refrain from laughing, for he was not sitting down, nor lying down, nor leaning against anything; he had slumped into an amorphous heap.

The will-o'-the-wisps, who up to that point had been occupied with him, stepped to one side. Although pale in the morning light, they seemed well fed once more and in good flame. With their sharp tongues they had cleverly licked the veins of gold from out of the innermost parts of the massive statue. For a while the irregular empty spaces they

had thus created remained open and the statue retained its former shape. But when the last, most delicate little veins had been consumed, the statue collapsed all at once and, unfortunately, at precisely those places that remain straight when a person sits down; his joints, however, which ought to have bent, remained rigid. Those who could not laugh had to turn their eyes away; the object that was half shaped, half a shapeless mass, was a repulsive sight.

Now the man with the lamp led the handsome youth, who was still staring fixedly into space, down from the altar and towards the bronze king. At the feet of the powerful prince lay a sword in a bronze sheath. The youth girded himself with it.

'Sword on the left, the right hand free,' cried the mighty king.

After that they went to the silver king. He brought his sceptre down towards the youth, who grasped it with his left hand. In a sweet voice the king said, 'Feed thy sheep.'

When they came to the golden king, with a fatherly gesture of blessing he placed a circlet of oak leaves on the youth's head, saying, 'Know the highest wisdom.'

While this was happening the old man observed the youth closely. After he had girded the sword, his breast rose, his arms moved and his feet stood more firmly on the ground; as he took the sceptre in his hand, his strength seemed to grow milder and yet, through some charm beyond expression, even mightier; but when the circlet of oak leaves adorned his brow, his features came to life, his eyes shone with a

radiance of spirit beyond expression, and the first word to cross his lips was *Lily*.

'Dear Lily,' he cried as he hurried up the silver steps towards her – for she had watched him from the top of the altar as he went to the three kings – 'dear Lily, can a man who has been equipped with everything wish for anything more precious than the innocence and quiet affection you bear in your bosom for me?

'O my friend,' he went on, turning to the old man and looking at the three holy statues, 'magnificent and secure is the realm of our fathers, but you have forgotten the fourth power, whose rule over the world was earlier, wider and more certain: the power of love.'

With these words he flung his arms round Fair Lily's neck. She had cast aside her veil and the blush that coloured her cheeks was the most beautiful, most unchanging imaginable.

At that, the old man said with a smile, 'Love does not rule, but it shapes things, and that is more.'

They had been so absorbed in the solemnity of this moment, the happiness, the delight, they had not noticed that day had fully broken. All at once the company became aware of some quite unexpected objects through the open doorway. The forecourt was a large square surrounded by pillars at the end of which a long and magnificent bridge could be seen crossing the river with many arches. With arcades on either side, it was magnificently and conveniently furnished for pedestrians, many thousands of whom had already arrived and were busily going back and

forth. The broad road in between was full of herds of cattle, mules, riders and carriages, which streamed back and forward on both sides, without getting in each others' way. They all seemed astonished at its convenience and magnificence, and the new king and his spouse were as delighted at the activity and life in this great crowd of people as they were happy at their mutual love.

'Hold the memory of the snake in honour,' said the man with the lamp. 'To her you owe your life and your people the bridge, by which alone these two neighbouring sides are joined and brought to life as countries. Those precious stones which glowed as they floated on the water, the remains of the body she sacrificed, are the foundations of this magnificent bridge, on which she has erected herself and will preserve herself.'

They were about to ask him to explain that strange mystery when four beautiful maidens entered the temple. They immediately recognised Lily's companions by the harp, the parasol and the folding chair, but the fourth, more beautiful than the other three, was unknown to them. She hurried across the temple, laughing with her sisters, and climbed the silver steps.

'Will you trust me more in the future, my dear?' said the man with the lamp to the beautiful maiden, who was no other than his wife. 'Fortunate are you and every other creature that bathes in the river on this morning.'

The old woman, rejuvenated and beautified, had no trace of her former appearance. She threw her

invigorated, youthful arms round the man with the lamp, who accepted her caresses with calm pleasure.

'If I am too old for you now,' he said with a smile, 'you may choose another husband today. From today no marriage vows are valid that have not been renewed.'

'Do you not know,' she replied, 'that you too have become younger?'

'I am glad that your young eyes see me as a fine young man. I take your hand anew and am happy to share my life with you in the millennium that is to come.'

The queen welcomed her new friend and went down with her and her companions inside the altar, while the king stood between the two men, looking across at the bridge and watching the crowds of people closely.

But his content was short-lived, for he saw something which put him in an ill humour for a moment. The great giant, who did not seem to have fully woken up yet, was staggering across the bridge, sending everything into disarray. As always, he had got up, still heavy with sleep, with the intention of bathing in his usual inlet, and when he found it was dry land, he had lumbered along on the broad carriageway of the bridge. Although he was stepping most clumsily among people and animals, everyone was amazed to see him, but no one was hurt. However, when the sun shone in his eyes and he raised his hands to rub them, the shadow of his immense fists went so powerfully and so clumsily to and fro among the crowd behind him, that great masses of people

and animals fell over, were harmed and in danger of being flung into the river.

When he saw this outrage, the king's hand automatically went to his sword, but after a moment's thought he looked calmly first at his sceptre, then at the lamp and the oar of his companions.

'I can guess what you are thinking,' said the man with the lamp, 'but our powers cannot control this being who cannot control himself. Do not worry, it is the last time he will cause harm, and fortunately his shadow is on the side away from us.'

In the meantime the giant had come closer. Amazed at what he could see with his own eyes, his hands had dropped and he did no more damage. Gaping and gawping, he came into the forecourt.

He was heading straight for the temple door, when all at once he was fixed to the ground in the middle of the courtyard and remained standing there, a colossal, massive statue of a reddish, shiny stone whose shadow showed the hours, which were set into the ground in a circle around it, not as numbers but as fine, significant images.

The king was quite delighted to see the monster's shadow put to some practical use, just as the queen was quite amazed, when she emerged with her maidens from the altar, magnificently apparelled, and went up the stairs, to see the strange image that almost completely blocked the view from the temple to the bridge.

Meanwhile the people came thronging after the giant, now he was no longer moving, surrounding him and marvelling at the transformation. Then the

crowd turned to the temple, which it seemed only now to have noticed, and pressed towards the door.

At that moment the hawk hovered high above the dome, caught the light of the sun in the mirror and reflected it onto the group standing on the altar. The king, the queen and their companions appeared, picked out against the half-light of the vaulted temple by a heavenly radiance, and the people prostrated themselves before them. When the crowd had recovered and risen to its feet again, the king and his companions had descended into the altar, to go by hidden passageways to his palace; the people dispersed around the temple to satisfy their curiosity. They looked on the three upright kings with amazement and awe, but they were all the more curious to know what the shapeless mass was that was concealed under the tapestry in the fourth recess, for someone, a person of tact and consideration, had thrown a splendid cover over the collapsed king which no eye could penetrate and no hand dared to lift.

The people could not get over their amazement and admiration, and the crowd pressing into the temple would have crushed themselves, if their attention had not been drawn to the great square again.

Without warning, as if they came out of thin air, gold coins started to rain down, jingling on the marble slabs, and those closest rushed over to grab them. This miracle was repeated several times, in different places. As you will realise, it was the will-o'-the-wisps who, as a farewell gesture, were amusing themselves

by throwing away the gold from the limbs of the collapsed king. Greedily the people ran to and fro, pushing and tearing at each other, even when no more gold coins were falling. At last they gradually dispersed and went their separate ways, but even today the bridge is still swarming with travellers and the temple is the most visited spot on the whole earth.

Dedalus European Classics

Dedalus European Classics began in 1984 with D.H. Lawrence's translation of Verga's *Mastro Don Gesualdo*. In addition to rescuing major works of literature from being out of print, the editors' other major aim was to redefine what constituted a 'classic'.

Titles available include:

Little Angel – *Andreyev* £4.95
The Red Laugh – *Andreyev* £4.95
Séraphita (and other tales) – *Balzac* £6.99
The Quest of the Absolute – *Balzac* £6.99
The Episodes of Vathek – *Beckford* £6.99
The Fiery Angel – *Bruisov* £9.99
The Devil in Love – *Cazotte* £5.99
Undine – *Fouque* £6.99
Misericordia – *Galdos* £8.99
Spirite – *Gautier* £6.99
The German Refugees – *Goethe* £6.99
The Dark Domain – *Grabinski* £6.99
The Life of Courage – *Grimmelshausen* £6.99
Simplicissimus – *Grimmelshausen* £12.99
Tearaway – *Grimmelshausen* £6.99
The Cathedral – *Huysmans* £7.99
En Route – *Huysmans* £7.99
The Oblate – *Huysmans* £7.99
Parisian Sketches – *Huysmans* £6.99
The Other Side – *Kubin* £9.99
The Mystery of the Yellow Room – *Leroux* £8.99
The Perfume of the Lady in Black – *Leroux* £8.99
The Woman and the Puppet – *Louÿs* £6.99
Blanquerna – *Lull* £7.95
The Angel of the West Window – *Meyrink* £9.99
The Golem – *Meyrink* £6.99
The Green Face – *Meyrink* £7.99
The Opal (and other stories) – *Meyrink* £7.99

The White Dominican – *Meyrink* £6.99
Walpurgisnacht – *Meyrink* £6.99
Ideal Commonwealths – *More/Bacon et al* £7.95
Smarra & Trilby – *Nodier* £6.99
The Late Mattia Pascal – *Pirandello* £7.99
Tales from the Saragossa Manuscript – *Potocki* £5.99
Manon Lescaut – *Prévost* £7.99
Eugene Onegin – *Pushkin* £7.99
Cousin Bazilio – *Queiroz* £11.99
The Crime of Father Amaro – *Queiroz* £11.99
The Mandarin – *Queiroz* £6.99
The Relic – *Queiroz* £9.99
The Tragedy of the Street of Flowers – *Querioz* £9.99
Baron Munchausen – *Raspe* £6.99
Bruges-la-Morte – *Rodenbach* £6.99
The Maimed – *Ungar* £6.99
The Class – *Ungar* £7.99
I Malavoglia (The House by the Medlar Tree) – *Verga* £7.99
Mastro Don Gesualdo – *Verga* £7.99
Short Sicilian Novels – *Verga* £ 6.99
Sparrow, Temptation & Cavalleria Rusticana – *Verga* £8.99
Micromegas – *Voltaire* £4.95

German Literature from Dedalus

Dedalus features German Literature in translation in its programme of contemporary and classic European fiction and in its anthologies.

Androids from Milk – *Eugen Egner* £7.99
Undine – *Fouqué de la Motte* £6.99
The German Refugees – *Johann Wolfgang Goethe* £6.99
Simplicissimus – *J. J. C. Grimmelshausen* £12.99
The Life of Courage – *J. J. C. Grimmelshausen* £6.99
Tearaway – *J. J. C. Grimmelshausen* £6.99
The Great Bagarozy – *Helmut Krausser* £7.99
The Other Side – *Alfred Kubin* £9.99
The Road to Darkness – *Paul Leppin* £7.99
The Angel of the West Window – *Gustav Meyrink* £9.99
The Golem – *Gustav Meyrink* £6.99
The Green Face – *Gustav Meyrink* £7.99
The Opal (& other stories) – *Gustav Meyrink* £7.99
Walpurgisnacht – *Gustav Meyrink* £6.99
The White Dominican – *Gustav Meyrink* £6.99
On the Run – *Martin Prinz* £6.99
The Architect of Ruins – *Herbert Rosendorfer* £8.99
Grand Solo with Anton – *Herbert Rosendorfer* £9.99
Letters Back to Ancient China – *Herbert Rosendorfer*
 £6.99
Stefanie – *Herbert Rosendorfer* £7.99
The Maimed – *Hermann Ungar* £6.99
The Class – *Hermann Ungar* £6.99

Anthologies featuring German Literature in translation:

The Dedalus Book of Austrian Fantasy –
 editor M. Mitchell £11.99
The Dedalus Book of German Decadence –
 editor R. Furness £9.99
The Dedalus Book of Surrealism –
 editor M. Richardson £9.99